Singleness

CHOICES

GUIDES FOR TODAY'S WOMAN

Singleness

Dorothy Payne

The Westminster Press
Philadelphia

Copyright © 1983 Dorothy Payne

All rights reserved—no part of this book may be reproduced in any form without permission in writing from the publisher, except by a reviewer who wishes to quote brief passages in connection with a review in magazine or newspaper.

Scripture quotations from the Revised Standard Version of the Bible are copyrighted 1946, 1952, © 1971, 1973 by the Division of Christian Education of the National Council of the Churches of Christ in the U.S.A., and are used by permission.

Book Design by Alice Derr

First edition

Published by The Westminster Press®
Philadelphia, Pennsylvania

PRINTED IN THE UNITED STATES OF AMERICA
9 8 7 6 5 4 3 2 1

Library of Congress Cataloging in Publication Data

Payne, Dorothy.
 Singleness.

 (Choices : guides for today's woman)
 Bibliography: p.
 1. Single women—Psychology. 2. Single women—Social conditions. 3. Single women—Conduct of life.
I. Title. II. Series: Choices.
HQ800.2.P39 1983 305.4'890652 83-10174
ISBN 0-664-24541-2 (pbk.)

CONTENTS

Acknowledgments	9
Introduction	11
1. Understanding Singleness	15
Who Is the Single Woman?	16
Religious Understandings of Marriage and Singleness	19
Language About Singleness	20
Reasons Why Women Are Single	21
Feelings of Single Women	23
2. Stereotypes and Discrimination	26
Stereotypes	27
Discrimination	29
3. Coping with Common Problems	32
Low Self-Esteem	32
Loneliness	35
Fear	41
4. Meeting Our Needs	47
Sexuality	49
Relationships	54
A Home	63
Economic Security	65

5. OPPORTUNITIES FOR SINGLE WOMEN	68
Freedom	68
Self-Determination	71
Self-Development	74
Involvement with Others	78
Learning and Growing/Next Steps in Growth	83
6. GOD'S GIFTS FOR SINGLES	85
Rootedness	85
Community	87
Celibacy	90
Comfort	95
Belonging	99
Fulfillment	103
AFTERWORD	108
BIBLIOGRAPHY	111

PUBLISHER'S ACKNOWLEDGMENT

The publisher gratefully acknowledges the advice of several distinguished scholars in planning this series. Virginia Mollenkott, Arlene Swidler, Phyllis Trible, and Ann Ulanov helped shape the goals of the series, identify vital topics, and locate knowledgeable authors. Views expressed in the books, of course, are those of the individual writers and not of the advisers.

ACKNOWLEDGMENTS

This book would not have been possible without the support, patience, and help of many people. I did not write this book alone: many women told me their stories, shared with me important concepts and ideas, and taught me invaluable aspects of the human spirit. I have stood in amazement and wonder at the generosity of many, the valiancy of the human soul, the ability to survive in the midst of intolerable odds. It makes me sad that I cannot name them all, but that is impossible, since many helped me without even knowing.

There are a few people who have given of themselves so generously that I must name them here.

Peggy Lasseter has been my right hand throughout. She has encouraged, goaded, given important feedback and insights, tolerated my bad times, read the manuscript with painstaking thoroughness, and discussed all aspects of the work carefully and thoughtfully. Deep gratitude goes to Peggy.

I gladly pay tribute to my colleague and friend Kathy Wagner, who so patiently and with such good humor exhibited amazing ability to cope with the manuscript, the daily round at New Berith, and me, all at the same time.

There are a few single women to whom I gladly pay tribute for their trust, love, encouragement, and help. They are Valerie Flamberg, Linda Kolstee, Sister Elizabeth, and Edith Wheeler.

Others who contributed in a variety of unique and important ways were Helena Chojnacka, Eugenia Fischer, Lisa Gritti, Doris Kersten, Shirley Powers, and Marla Schmitt. Volunteers at New Berith whose dedicated clerical work released my time for the book were Marion Landolt, Ina Southmayd, and Stevie Wilcox. Each of these women deserves hearty thanks.

Lastly, but by no means of least importance, a very special word of thanks goes to my friend Loree Elliott, who has been unstinting with her time, her sensitive listening ear, her concern for all human beings, and her love for God and the world, which have been an inspiration and beacon to me for the past twenty-eight years. She above all has helped me understand, trust, and enjoy myself, and thus my singleness.

INTRODUCTION

My crisis as a single woman began when I was thirty-eight and realized that I probably would never marry again. I had been both widowed and divorced, my father had died, and I had lost a child. These usual sources of a woman's identity had been swept away.

During the ensuing years I searched in many possible directions for help. At that time, from 1956 to 1965, schools did not have programs to educate women in midlife. Churches were interested in families. Social clubs and organizations for single people wanted members under thirty-five. A good deal of housing and even some apartments were refused to single women with limited funds.

The cultural attitudes I discovered toward single women affected me deeply. I was shocked and dismayed at how their great power and potential were not only wasted but denied altogether. Many years later I am glad to say that changes have been made, though not thoroughly enough or quickly enough.

For me, the turnaround came when I began understanding that to be single and thirty-eight was not the end of life but could be a fresh beginning. I came to realize through loving friends that there is a God who

cares and loves, a Spirit who calls us to new life and supports us in our search for different values and the inner power that is ours. I came to know that single women have to unlearn old patterns that no longer work for them, and replace those patterns with new attitudes and responses. Thus we move toward being women who realize their potential for newness, freedom, strength, and joy.

At the age of forty, circumstances in my life took a sharp turn, which led me to attend Princeton Theological Seminary. I had a "sudden conversion." Not only had I been "turned on to Jesus" but I had been given a mission as well: only a few days after my experience it became very clear to me that something must be done about the powerless condition of the single woman in our society.

After graduation from Princeton Seminary I lived for several years in a women's hotel in New York City ministering to the women there. During that time I wrote my first book, *Women Without Men,* finished my courses for an M.Div. degree at New York Theological Seminary, developed Ministry with Single Women, Inc., and did counseling and speaking about women. During the four years after I received my M.Div. degree I continued my ministry to women, worked at New York Theological Seminary as dean of Lay Theological Education, and developed classes for women in various parts of the metropolitan area.

In 1974 a group of women founded the house that has become the New Berith Women's Center in White Plains, New York, and is headquarters for Ministry with Single Women. Thousands of women have come to the Center for workshops, retreats, classes, social events, Bible study, worship, and counseling, all geared particularly toward the single woman. During these years of ministry, I have talked with thousands of single women about their lives, problems, and concerns. These women

are for the most part middle class, aged twenty-five to fifty-five, and of many faiths and nationalities.

All this has impelled me to write this book so that I can share with you what I have learned and tell you how I have found a life I could not have imagined a few years ago. I am indebted to the women who have shared with me and taught me so much. I am also thankful for the works of many authors whose knowledge and experiences have enriched my thinking and my life.

You and I live our lives one day at a time, trying to cope with this rapidly changing world and society in the best way we can. As I recount the highlights of my own life and of those of many other women, I hope this book will touch a vital chord in your life. As we women share our stories, we will discover common roots, images, and strengths.

We live in a world where there is a growing acceptance of the single state for women. I believe, and hope you do too, that each woman should have a free choice about her life. I am certainly not against marriage, having been married twice myself, nor am I trying to make light of the many disadvantages of being single in a couples' world. But I hope that if you find yourself single, this book will suggest new ways for you to enjoy yourself and will help you to remain single happily if that is what you choose. For the first time in history single women may enjoy a life with meaning and fullness, with positive energies released for their well-being and for helping others.

CHAPTER 1

Understanding Singleness

You and I know that people around us expect us to want to marry. Do they or do we have a clear picture of what being single really is? In this chapter we will see how we can say yes to singleness despite several sources of uncertainty. We will answer the question, "Who is the single woman?" Next we will examine two sources of our mixed feelings about singleness, religious understandings of marriage and singleness, as well as the language that describes singleness. Afterward we will explore many reasons why women are single, and finally we will record the strong feelings of various kinds of single women.

Many women presently single feel they would like to marry but are unable to for a variety of reasons. They have mixed feelings about taking care of themselves, expressing their deepest feelings, or spending time and energy outside of marriage. Some feel confused about whether they "ought" to be married, to meet their own or other people's expectations. Most single women feel this way sometimes. Can they be whole, fully developed, happy people and be single? Yes, definitely, but they need to make wise choices to meet their own needs and use their talents. All that a person needs—love, friend-

ship, security, a home—can be found by the single person.

Recently many women have become aware that marriage is not the only viable life-style. Today more women are looking at their alternatives, analyzing the reality of their situation, and deciding for themselves how they want to live their life.

But choice is difficult. It is painful to look within to find satisfaction and joy. The illusion may exist that someone "out there" will rescue one from the need to make decisions.

An old Spanish proverb declares, "Choose what you will and pay for it." If a woman does not choose consciously, if she allows illusion to rule, she will suffer the consequences. Learning to choose between several alternatives rather than taking the way of least resistance depends primarily upon her willingness to take responsibility and her openness to the transforming Spirit.

The real question, then, is not, "When will I get married?" or "When will I get *re*married?" or "What's wrong with me that I'm not married?" The question should be, "What particular life-style will be most fulfilling for my particular personality and gifts?" "How will I use being single to respond to God's call to be in relationship with the Spirit, myself, and others?" You and I must decide to be the most alive, centered, giving, and receiving creature possible, regardless of marital status.

The important thing is to follow our own inner heart, not the pressures of people around us. At the same time, we need to feel confident despite many sources of uncertainty.

WHO IS THE SINGLE WOMAN?

She is difficult to define. Despite the fact that statistics indicate that one third of our population is now single

and that one out of three people who marry eventually divorce, the attitude of many people today—even in our churches—is much the same. Often single women are still surprised to find that they are not alone in their struggle.

The single woman is divorced, widowed, a nun, a former nun, a lesbian, never married, separated from her spouse or lover, celibate. The single woman is varied in status. She is wealthy and abysmally poor. Her roots are in every nationality, class, race, religious affiliation, and political persuasion extant. Look around you and you will find she exists—though still rather silently—in almost every large family, every church and synagogue, all large business organizations. She is brilliant or stupid, fierce or compassionate, emotionally strong or weak, and all shades in between. She lives in tiny rooms with hot plates, in institutions, lavish homes, run-down rooming houses, and comfortable apartments. She dwells alone and with others. She sometimes lives on the street. Most often her dwelling is a modest efficiency or one-bedroom apartment. The single woman, like everyone else, is in varying phases of psychological growth and of sexual, social, chronological, and spiritual development.

As with everyone else, her situation is partly by choice and partly by chance—or is it providence? Like everyone else, she is partly trapped and partly free. Like everyone else, she is both tied and loose. As unique individuals, some feel more tied and trapped, while others feel more loose and free even though their circumstances may be similar.

Like everyone else, she is lonely and has opportunities, whether she takes advantage of them or not, to overcome her loneliness in friendship and community. There are those single women who are so lonely and out of touch that the hope of developing any relationship is dim.

Like everyone else, the single woman needs to be needed and wants to be useful beyond working from nine to five or keeping up a house or an apartment. She may not know there are ways she can be of service, a source of fulfillment for many.

If she is employed, she probably gets paid less than men. Her chances for significant work and for job advancement are limited even though she has more opportunities than ever before.

Each of our millions of single women will be living a variety of different roles during her lifetime. She must try to find balance and meaning in life while, all around her, traditional values are being seriously questioned. She may be envied by other women for her freedom and her status, though still a second-class citizen under some laws and still functioning in a man-oriented culture. Strides have been made toward justice in the past ten years, but the single woman must keep moving forward.

The role of the successful single woman is a demanding one. She must be strong both physically and emotionally to stand on her own and alone. Unless she has an independent income she must establish herself as capable and reliable to compete in the job market. She must be self-confident and poised to gain the respect of fellow workers and employers which she needs to get ahead. If she chooses a life of service, which is usually poorly paid, she will need to find a full life without substantial material comforts and rewards.

Every single woman must be brave. Living alone, especially in our crime-ridden society, is full of fearful possibilities.

To establish a social life for herself she must be resourceful, sometimes exerting considerable effort. Especially if she lives alone, she needs to seek opportunities to meet and socialize with others.

RELIGIOUS UNDERSTANDINGS OF MARRIAGE AND SINGLENESS

One reason why some single women are discontented is that they mistakenly think that marriage is God's only plan for women. Yet Catholic nuns have long developed ways of carrying out God's will as single people. They point to Paul's arguments that being unmarried leaves one freer to serve God in serving other people.

There are a variety of reasons why most women who take religion seriously do feel pressure to be married. Frankly, churches and synagogues are family-oriented, with family suppers, couples clubs, and children's religious education. Too often we single people are seen as irrelevant or even threatening to this family togetherness. Another reason why singles feel religious pressure to marry is the conviction that sexuality can be appropriately expressed only in marriage. This mistaken notion will be discussed later in terms of Christian ethical principles.

Some people are wrongly convinced that the Bible tells everyone to be married. They point to the significance of marriage and family relationships in the Old Testament, forgetting the tribal reasons no longer applicable to Jesus' time or our own. By contrast, in the New Testament the blood family fades into the background as do all earthly relationships of husband and wife, parent and child, ruler and subject, master and slave. The body of Christ includes all who turn to Christ and believe in him regardless of their condition of life, marital status, race, or sex, and this is possible because of "the riches of God's glory" (Eph. 3:16).

Meaningful identity is found in relationship to others, the world, and the Spirit. God intended it that way from the very beginning when Yahweh announced, "It is not

good that the man should be alone" (Gen. 2:18b). The entire biblical tradition calls us to reconciliation with God and with one another, to love for ourselves toward others and for God. It is not mandatory, however, that such relationships be marital. A single person wishing to serve God may be called to many different relationships rather than one primary one.

In I Corinthians 7, Paul makes it quite clear that the opportunity to fulfill one's call or purpose in life and thus become truly human, re-created in the image of God, does not depend upon social or marital status.

LANGUAGE ABOUT SINGLENESS

"When *I* use a word," declared Humpty Dumpty, "it means just what I choose it to mean." I wonder how many of us are so clear about the way we use words?

Words are a reflection of a culture and they mirror attitudes of the past. Nevertheless, linguists agree that new ideas and changes in customs are constantly creating words. Probably more important, these new words themselves often spur, shape, or solidify social change. We have certainly seen this in both the black liberation movement and the women's movement.

Now it is time for *single* women to look at the language they use about themselves and allow the culture to use about them. We seem, at the moment, to be stuck with a language that fails to give positive recognition to those adult women who are, whether by circumstance or choice, single. Many words used for the single woman blatantly describe her as being *without* something: unmarried, unwed, unattached, divorced, separated, formerly married, spouseless, never married. "Bachelor girl" suggests that, unless a woman is married, she is a "girl," an immature member of society. Words such as "spinster," "old maid," and "celibate" have derogatory

connotations drawing forth images of someone who is dried up, unattractive, and even unsociable.

Even the continued use of "single woman" persists in setting apart women who do not marry, or who do not remarry if they are widowed or divorced, defining women through their relation to a husband. We are left with words such as "single," "solo," "sole." We must reshape the common vocabulary by using positive words and expressions, even coining new ones. In this way we can increase our own self-respect and the respect others have for us.

REASONS WHY WOMEN ARE SINGLE

Like everyone else, single women have come to their present place in life partly through their own conscious choices, partly through circumstances, and partly through psychological reasons. Because women are such varied individuals, there are many different reasons why they are single in a society that expects adult women to be married.

Single Through Choice. Some women have chosen a single life in a positive and deliberate way. Some women feel they do not have time for a deep relationship. Their priorities are to be successful in business or in the arts. Some have been pioneers in medicine and law, working so hard to get through school and develop a practice that they have given up marriage for the sake of their work. Other women choose not to be married in order to have the freedom to live adventurously. It is no longer so rare to discover women who have chosen to be single because they like to be alone a great deal. Some women choose to remain at home to care for ailing parents. Missionaries who go overseas or who are assigned to dangerous areas may not marry because they feel it

would be unfair to husband and children. Some women want to prove that they can make it on their own without depending on another person. Many of these women are successful, fulfilled, and satisfied with their choice to remain single.

Single Through External Circumstances. Women may be single because of the death of the husband, or because of rejection by the husband through divorce. Some women are single because there are not enough men to go around and these women have not been at the right place at the right time to form attachments with eligible men. Other women have been absorbed by other demands, such as caring for a disabled member of the family. Still others suffer some physical disability or handicap which prevents them from marrying.

Single for Psychological Reasons. Among the many things that interfere with women becoming involved in marriage are the following:

 fear of intimacy and love
 dislike of men
 strong wish for independence
 unwillingness to live with a less than perfect situation or person
 unrealistic dreams about relationships
 unrealistic expectations of a man
 unwillingness to share time and energy
 qualities that intimidate many men, such as aggressiveness or competitiveness
 sexual attraction to women rather than to men
 lack of social skills in conversation and dating
 memories of earlier difficulties with men
 uncertainty about what one wants

FEELINGS OF SINGLE WOMEN

In the late 1970s I developed three retreat/workshops for single women: one for women who had never married, one for divorced and separated women, and another for widows. The following trends were evident.

Feelings Common to Women in All Three Groups. The never-married, the divorced and separated, and the widows expressed these concerns:

- the struggle with loneliness
- fear of the future
- a sense of worthlessness
- inadequacy: Can I stand alone? Am I capable of doing anything worthwhile?
- the feeling that no one understands them
- strong individuality in the ways through which they express themselves
- eagerness to learn and grow once they glimpse the possibilities
- a tendency to put themselves down until made aware of what they are doing
- an interest in knowing how and where to meet other people, especially men
- anger at a couple-oriented, prejudiced society
- conflicting emotions

Feelings of Never-Married Women. The groups were comprised mostly of working or professional women. Among the tendencies expressed by the never-married were these:

- eagerness to meet others
- tendency to be busy and interested in many things, sometimes overworking

the feeling that the church and society in general are
 not interested in them
inclination to be opinionated
general self-confidence

Feelings of Divorced and Separated Women. Women who had been divorced or separated expressed the following:

a tendency to hate themselves
feelings of guilt and shame
a sense of failure and sometimes hopelessness
confusion about themselves, especially emotionally
frequent hostility or anger, even bitterness
assertiveness more pronounced than in some other
 women
general eagerness to learn and grow
great impetus to move forward
tendency to take one of two roads: (1) To never,
 never marry again because they have been hurt so
 deeply, or (2) to pursue a hectic pace searching for
 anyone who might briefly provide them with di-
 version or a sense of being wanted in order to
 assuage the hurt, anger, and feelings of failure that
 haunt them.
the ability to surface anger more readily than most
 groups in working through loss and grief

Feelings of Widows. Variations depended partly on how long these women had been widowed, and whether their husbands died suddenly or after a long illness.

the feeling of being uncared for
intensity of some in working through grief
a tendency to idealize the marital relationship, some
 to a dangerous degree
a tendency to live in the past

- difficulty in verbalizing anger or admitting it
- emotional insecurity, because more than the other two groups, they are used to being dependent
- basic questioning about God, death, life, justice
- fear of facing the future
- tendency to self-pity. This trait is also common in many divorced women and, to a lesser degree, in the never-married women, but seemed more pronounced in the widows
- more sensitivity and compassion toward problems of death and grief in the lives of others

Although both widows and divorced women must deal with grief, loneliness, guilt, and anger, the divorced woman often blames herself for the failure of the marriage, while the widow's situation came from forces outside herself that she could not possibly control. In spite of this, as participants verbalized what they had experienced, both groups agreed on the following statements: (1) "Married friends no longer include me. I feel isolated and out of touch." (2) "I have no one with whom to share deep feelings, activities, love, touch, intimacies on a daily basis." (3) "Family and friends are suspicious and often critical when I try to make friends with the opposite sex." (4) "Children ask questions about their fathers, sex, the men in my life, what I do when I go out, questions that often lead to confusion or guilt." (5) "The many problems of being the sole breadwinner, possibly for the first time in my life, are sometimes overwhelming."

As we can see, each single woman has special feelings, unique to her circumstances. Her feelings are determined by age, the fact that she is a woman, her financial condition, her personality, and, of course, whether she has always been single or has recently reentered the single state.

CHAPTER 2

Stereotypes and Discrimination

Single women are often not understood, and because of distorted and stereotyped ideas, they experience inappropriate treatment. Stereotypes are generalizations that classify people. They allow no room for variety, human differences, or individuality, but are repeated over and over without variation, nuance, or color. A statement heard often enough begins to be believed whether it is true or not. When people accept a stereotype or a prejudice about others, they tend to treat them differently and often with less favor. We call this *discrimination*.

One of the first steps toward freedom from stereotypes and discrimination is developing a conscious awareness of what is going on—both inside in our own minds and outside in our cultural environment. For we are shaped both by the changes that are thrust upon us by life and by the inner responses we make to those changes. Sometimes awareness means facing uncomfortable feelings of anger, fear, even rage. It hurts to confront destructive ideas, to stand up for what we believe to be a more realistic image. Reexamining possibilities and developing new responses, rather than accepting things as they have always been, is one of the marks of a growing personality.

Let us look at some of the ways our culture sees single women. Do we like what we see and hear? If not, what will we do? What will *you* do?

STEREOTYPES

One stereotype that many people still hold is that if a woman over thirty is unmarried, she must be physically unattractive, probably leads a quietly monotonous life (although she seldom complains), and is not feminine. She is seen as a half person, incomplete, odd, and probably boring, prudish, and sexually incompetent. A different stereotype sees the single woman as footloose and fancy free, leading an exciting, stimulating life and having a lot of men friends. She is a swinger who is invited to a party every night and to glamorous places for adventurous weekends. These stereotypes range from one extreme to the other and are obviously contradictory.

Over the years, I have collected stereotypes about single women from literature, television, and women themselves. On the whole, those stereotypes are demeaning and depressing. The single woman is supposed either to hate or to fear men, or to be a promiscuous lover. She is portrayed as selfish, only interested in her own life, unwilling to share with others. Reality is far different. Nevertheless, stereotypes of single women confront us both from people we know and from the media which inform our society.

The other day a young woman said to me: "I always think of widows as pathetic little old ladies eating alone in restaurants and sitting in the back pew at church. I know the image is wrong. I have a friend whose husband was a policeman killed in the line of duty. He was only twenty-six. Still, I can't get the old picture out of my head when I hear the word 'widow.'"

Stereotypes picture marriage as the only acceptable

life-style. "When are you going to settle down?" "It's too bad a beautiful woman like you isn't married." "Aren't you two married yet?" "You can't be *really* happy alone," are phrases often repeated by unthinking people. Even at church, where she has the right to expect acceptance and understanding, the single woman is often left to herself, or, worse, invited to "Come to the potluck supper. We'll find someone to sit with you."

The media project stereotypes that do not portray people realistically. Most of the time there is only one type of model for women. She is white, skinny, young, artificial, and extremely energetic. She has a broad smile, white-white teeth, and long glossy, flowing, bouncy hair. Very few women fit that pattern, but millions of them become restless and dissatisfied with themselves because they cannot do so. In contrast, other messages haunt us with the possibility that we smell bad, shed dandruff, have a film on our teeth, sag or stick out where we should not, and cannot sleep. The implied threat is that only by using the magic products packaged for our improvement can we fool people into liking us.

The media also perpetuate stereotypes of women as being all happily married. If we were like the advertisements on television, we would all have children and a home where we bake cakes from packages, keep our floors spotlessly clean, find it difficult to choose between two or more brands, and keep our hands soft with the proper dishwashing soap so that we will look as young as our youngest daughter.

Repetition of stereotyped images makes us uncomfortable and pounds our subconscious with a desire for the product. It takes a conscious effort to remember that what we really need is a deep spiritual life, a strong value system, and faith in the diversity and beauty of each individual soul.

DISCRIMINATION

As a result of these stereotypes, any woman alone faces concrete problems as other people act on these stereotyped beliefs. Here are a few statements made by some of the women I talked with. See if any of the following conditions still apply where you work and live:

- Waiters and waitresses give a single woman a poor table, bad service, and hurry her through her meal.
- Dinner party hosts or hostesses are reluctant to invite a single woman if it will result in an odd number of guests at the table.
- Relatives and friends invade a single's privacy with questions about social matters that they would never dare ask a married woman.
- Single women are sexually harassed at work (as are some married women).
- Mechanics and repairmen overcharge and do inferior work for a single woman.
- Loan and mortgage companies still make it difficult for the single woman to get financing, or she may be denied altogether the right to buy or rent property.
- Employers may alienate singles by extending an invitation to a picnic or other outing that suggests that one is expected to bring the family or the spouse.
- Employers, often feeling that singles are less stable, more rootless, or less in need of a job than their married counterparts, pass them over for promotions, or require them to relocate or travel more frequently.
- Retreat houses, conferences, and workshops offer a discounted rate to couples.

Parents are more likely to invest in a son's education than in a daughter's because they assume that she will marry and have no need of it.

Churches with active couples clubs and family-oriented group activities seldom offer activities for singles who are over the age of twenty-five.

Legal discrimination against women is gradually being reduced. In housing, for example, new laws are gradually making it hard for a landlord to discriminate against children. Because landlords do not like the noise and mess of children, they often refuse them. Now, because in some places such discrimination is a criminal offense, landlords will allow children, making life easier for single women with children, who formerly had found much housing closed. In zoning, many areas used to be limited to one-family occupancy. Many women, unable to afford a place of their own, began to speak out about the need to live with others in order to survive. The return to the concept of the extended family is growing, and more housing is now open to shared housing and combined families.

One of the greatest things the women's movement accomplished was to make people aware that a woman can sue a man for sexual harassment and sexual abuse, even within a marriage. In the past she was either afraid to do so, did not know she had the legal right, or felt intimidated by the male, who was usually also an authority figure. Now she knows that she will not be considered at fault or lose her job when she brings to the attention of the authorities the reality of her situation. Sexual harassment or even sexual pressure is a crime and is now being treated as such. This new situation increases feelings of self-worth in a woman and causes men to change their attitudes toward women.

The modern women's movement has done us all a

great service by fighting for the basic ideas of equality that were evident in Christianity. But without the biblical basis or biblical imperative of discipleship, the movement, often strong on criticism, fails to establish a positive direction or model to look to beyond the criticism. It is now time for Christian women to speak out about the good news which is in our keeping.

CHAPTER 3

Coping with Common Problems

All people struggle to maintain self-esteem, combat loneliness, and overcome fear. As single women we need to draw on our own resources to maintain ourselves, since we have no person to look to automatically for support, company, and reassurance.

LOW SELF-ESTEEM

Self-esteem involves self-respect and confidence in one's own feelings and powers. Low self-esteem means feeling unworthy and unacceptable. Some therapists go so far as to believe that low self-esteem is the basic cause of many psychological problems. Self-esteem comes from within. We cannot achieve it only by being popular and having other people like us: we must learn to like ourselves. Even when one has gained some self-confidence, it is not easy to maintain that self-confidence since it must be questioned and reviewed with every change that life brings: age, relationships, job, residence. Each stage of life is a challenge to growth and trust in oneself. Certainly every single woman, regardless of her status, knows that very well.

At a recent women's meeting I asked the question,

"When did you experience the greatest growth in self-esteem?" Some of the answers were:

"When I look back on my life, I think I grew most in self-esteem at those times I chose to do something I wasn't sure I could do. When I did it, my self-esteem rose (I was a relative success), and I could risk the next step forward. In this way we gain confidence which is the antidote to low self-esteem."

"For me the real difference came when I had an experience of God's love. God creates each one of us and says we are good. Who am I to say that I'm not, in the face of that?"

"During my life I have felt the lowest self-esteem when I was not getting any feedback. Thus, I could not understand myself. This made me feel isolated. A friend came to me one day and gave me some negative feedback. It hit me deeply that I had been without honest evaluation for a long time. This friend said, 'I care enough about you that I want you to see this.' What mattered was that someone cared enough to be honest with me and to let me know how she saw me and the situation I was in. Most people would have said, 'Why bother?'"

Low self-esteem may lead a person to indulge in malicious gossip, become jealous, or have selfish ambition, which are never peaceable or open to reason and compassion toward others. They create disorder in relationships and in community. In a day when we single women need one another's friendship and support, it would be to our advantage to discipline ourselves to build one another up. Each of us has burdens enough to bear. Tenderness and gentleness, understanding and mercy can help lighten the load.

In order to gain self-respect and confidence in our powers and personality, we need to look at ourselves

realistically, accepting both the potential and the limits of our gifts.

When I recently asked a friend if she felt good about being single, she replied, "Isn't that the same as self-esteem?" I explained that we may have self-esteem and feel good about ourselves, but hate being single. When we do not like our single state, there is always the danger of lack of confidence and low self-esteem seeping into our beings. We need to affirm our state, enjoy ourselves, and enjoy life. We are not compelled to search for a mate or feel that we are not a whole person without a man by our side.

We are entering the era of the single woman. She is no longer under so much social pressure to marry and her opportunities are greater than they have ever been. The era is so new that there are few standards or rules, making it an alarming place for some women, though it can also give a sense of adventure about what is ahead. Being single, with the responsibility of life squarely on our shoulders, can be a position of strength if we will accept it. Looked at this way, singleness is an achievement to take advantage of, not a condition to escape from.

It is true that most women do want to get married. But until women or men are happy with themselves as single people, they are not really ready to be married.

Paul calls us to be happy in whatever state we find ourselves. Being single can be a blessing. It is an opportunity to learn to love ourselves, to have mercy on ourselves, to laugh at ourselves. The first state of any consciousness-raising is to discover the naked beauty of what we are, to celebrate our womanness, our youth, our age, our aloneness, so that we can celebrate life itself.

God meets us where we are and helps us accept with joy what is happening in the moment. If God is God at all, the Spirit is adequate for all the circumstances of life, including singleness.

For self-esteem, single women need to nourish themselves on deeply spiritual and meaningful things. I suggest a combination of the following:

> Read literary classics, the Scriptures, devotional material, biographies of great persons, diaries, and biographies of the saints.
>
> Listen to great music. At one stage of despair in my own life I bought four great recordings of Mozart. I played them over and over and found they penetrated my deep subconscious, healing me and restoring me to life.
>
> Read the psalms or other Scripture passages out loud to yourself.
>
> Try to turn your mind from thinking about problems.
>
> Try to be grateful for little things. We can choose to complain and be morbid, or we can choose to be grateful for life.
>
> Laugh as often as possible. Look for the humor around you.
>
> Take exercise of any kind: bicycling, swimming, walking, jogging, exercising with a program on television.
>
> Dance by yourself in your room, enjoying the flow of your body with the music.
>
> Buy a plant or an animal to care for.
>
> Play with color—watercolor, inks, tempera, acrylics, colored papers, yarn, anything that gives the joy of splashing color.
>
> Discipline yourself moment by moment. Take the first step, then the next.

LONELINESS

Loneliness has many expressions, many stages, and many effects. It can be constant or occasional, chosen or inflicted, normal or pathological, tolerable or unbear-

able. There is nothing simple about loneliness. Loneliness can strike anytime—in a crowd; in a group; at a church function, a party, a rap session; or when alone. It can happen to anyone and take different forms.

The Causes of Loneliness. The causes of loneliness are numerous and multifaceted. A few of them are rejection, grief, loss (one of the most devastating is loss of a loved one or a loved community), lack of purpose and meaning, fear, alienation, isolation, lack of roots, mobility, and shock. Loneliness can and often does come from actual deprivation: the loss of a favorite pet, memories of a lost youth, a past romance, a lack of social popularity, no one to share holidays with. We can experience loneliness when we refuse to reach out compassionately and creatively to others.

Those who observe the changes in the social order tell us that never before in the history of the world have individuals felt such a sense of insignificance and frustration. Not only have computers reduced their identities to a nine-digit Social Security number, but most of them feel helplessly caught up in an undertow of events beyond their control.

Paul Tournier, a prominent Swiss physician and psychotherapist, believes that there are four major causes of loneliness: the spirit of independence, the spirit of possessiveness, the spirit of just demands, and the parliamentary spirit. They are the result of competition; interest in ideas rather than in the people who have the ideas; fear of touching upon the personal; failure to help a person in difficulty because of being too detached, aloof, and busy; and lack of honesty in relationships. His antidote for both loneliness and its causes is to develop a spirit of fellowship.

When we study all the causes of loneliness, it is clear why so many single women feel lonely. Divorced wom-

en and the widowed, as well as most unmarried women who have refused marriage or been refused in marriage, have every reason, in our couple-oriented culture, to feel the depths of grief, loss, mobility, and other effects of this instability.

Distinction Between Loneliness, Aloneness, and Solitude. There is a difference between loneliness, aloneness, and solitude. Loneliness has nothing to do with being alone or isolated. It is a state of mental pain or anguish caused by feelings of separation, of being a nonentity, of nothingness. These feelings cannot be reduced to a single emotion, but ultimately a person feels that there is no one who cares for her. There is an element of helplessness in loneliness.

Being alone is simply being by one's self. When a person chooses to be alone, she usually is not lonely, but if she would rather not be alone, she will probably feel lonely. Thus it is important to discover some enjoyable solitary pursuits so that one can happily choose to be alone.

Solitude, in contrast, can be the most devastating of all loneliness, if we experience it as isolation. Or it can be an opportunity for great creativity.

It is the taste of utter solitude that makes us willing to search for a purpose, new values, a voice beyond the voices of the world of human beings. In a recent study done by psychologists in Chicago, it was found that adolescents attained heightened attention spans and powers of concentration after periods of solitude. The students themselves said that they were able to return to the company of other people feeling more alert, stronger, more involved, and more cheeful after periods of silence.

In his book *Reaching Out,* Henri J. M. Nouwen maintains that all creativity demands a certain encounter with loneliness. If we are afraid of solitude, we severely limit

our potential for deepening hospitable relationships and creative self-expression.

An author friend of mine, who has high regard for periods of silence and solitude, recently said to me: "I feel lonely most often when I am with other people. When alone, I feel lonely *only* when I have allowed myself to get overtired or when I have worked too long without refreshment and inner nourishment. Then I feel empty and need filling up. My most cherished times are those I spend in silence, alone except for the presence of God."

A woman recently widowed wrote to me: "I think it was that long period of excruciating loneliness that encouraged me to draw on my own inner resources. I've been happier ever since."

Though being alone has its advantages, giving us the ability to dream, study, practice, write, pray, we need to watch for the dangers. It is too easy for a woman who lives alone to become addicted to solitude. The ease of not having to bother about others, dress to go out among friends, polish social skills which may have become rusty, or stay current with issues in order to participate in the conversation may overcome the desire to be with others. Such a solitary world becomes ever narrower and more inward, destroying personality and energy, especially creative energy.

The goal of a healthy solitude is love: love and acceptance of ourselves as we are and where we are, and love and compassion for others. Thus the basis of solitude must be prayer, meditation, and contemplation. We fear such times alone because it is then that we have to face our inner selves: the untruths we have told, the unkindnesses we have committed, the many good deeds we have not done, the guilts and fears and hostilities we live with but will not admit to. Illusions may be easier to live with than realities, and there lies the real problem. The

answers to our deepest questions, our spiritual awakening, the assurance of pardon, and peace and joy lie within the depths of our own hearts. We touch these depths and see these truths only when we take time to listen to our own deepest longings, and allow the spiritual dimension of self to rise to consciousness and be accepted for what it is: a new song to sing, a treasure-house of new life, a fountain of healing waters rising up to eternal life.

Solutions. Here are a few of the possible solutions we can use in dealing with feelings of loneliness. This is by no means an exhaustive list. I encourage you to use your imagination and creativity in searching out your own solutions. Often the answer is in your own heart.
 1. If you are socially lonely, it is necessary to end the isolation. If the isolation is physical, make a deliberate effort to find a group whose interests, values, and goals are similar to yours. Stay in touch with its members and remember that in most cases it is only a matter of time until you will be accepted. Try not to arrive expecting that you will be taken in immediately. It takes time and social effort to become part of a group.
 2. Do not try to latch on to one person in the group but wait until some member or members of the group show an interest in you. Most of the anxiety you feel comes from fear of rejection. Sometimes it relieves tension to be able to say to yourself: "I'm feeling very anxious and afraid of being rejected. I must remember that most people I will be meeting may feel the same way and I must not take their anxiety to heart." On the other hand, try not to hang back shyly waiting for someone else to take responsibility for your social welfare.
 3. A woman in a rap group said recently: "I've been divorced for three years. Loneliness is my biggest problem. At 5:20 Sunday evening it was gray and rainy. I had

an anxiety attack because I was alone. I called *everyone* I knew—running away from the loneliness."

It is good to reach out to someone, but more important to try to face your loneliness. Take yourself in hand: try to think of an alternative. Too many frantic calls put a heavy load on any relationship and may end up creating the very situation you do not want: further rejection and aloneness.

4. Writing down how you feel or talking into a tape recorder can help to ease the panic and tension. No need to allow yourself to fall into self-pity and terror. Things do get better, and most bouts of loneliness are temporary. Even recognizing the truth of this can often set you on a more positive course.

5. Get involved in strenuous physical activity so that when you feel loneliness coming on you can relieve some of the tension through relaxation exercises, jogging, walking, swimming, or bicycling.

6. Take up an artistic activity: painting, singing, dancing, carpentry, cabinetmaking, flower-arranging, needlework, sculpture. Any activity in which you create something can lead you out of your feelings of isolation. Do something which, while making you feel good, enlivens your spirit and expands your mental horizons, such as taking a course, keeping a journal, developing a skill.

7. Learn to reach out to others. Establish a healthy degree of intimacy with one or more people by giving as well as receiving.

8. Work out feelings of loss, deprivation, grief, anger, failure and guilt, abandonment and fear. This can be done in self-help groups with a sympathetic listener or, in extreme cases, with a therapist.

9. Search out places like our Women's Center which provide an atmosphere of friendship where you can be yourself. You will find people who will listen to your joys and victories as well as your problems and defeats.

Single women can now find many rap groups where they can air their problems. Look for people and groups that are strong on support and weak on criticism. Choose groups that build up personality and encourage creative pursuits.

10. Get your facts, look at the bald truth of your situation, use self-discipline, and pray for trust in self, in other people, and in life, as well as for faith in God.

If anxiety, fear, and loneliness are the problems that face us, we have an opportunity to overcome them. They are all things that, with God's help and strength, we have the power to change.

FEAR

When a woman who is alone in the world says she is afraid, what is it she is afraid of?

I know from my own experience that a basic fear comes from recognizing and facing realistically one's basic aloneness. I have known it a number of times: when my parents were divorced, when first my husband and then my baby died, when I was divorced, and when my only living relative left my home. Each time I was forced to face the fact that I was totally responsible for myself, that I would have to cope alone with what life brought my way economically, socially, physically. There was no other half of a couple to make arrangements and take the initiative. Each time I was forced to take one more step toward adult maturity.

Some women like to sit back and have men take care of them. They like men to pay at the theater, in restaurants, in taxis. They find it comforting to have men open doors, chauffeur them around, be concerned that they do not get wet in the rain or snow. Men may lead the conversation and even go so far as to answer questions directed to

women. For such dependent women, doing many things for themselves is fearful.

Fears are as varied as are people themselves and often irrational. Some very young women have told me of their fears of falling or choking, and dying before being found, and their fear of disaster and not being identified. Some worry about illness, losing a job, and being alone. Many women will not drive a car because they fear accidents, driving in tunnels, the power of the car. One of the most persistent fears is that there will be no one to help in an emergency. Some women have other deep or trivial fears, such as:

- having a nosebleed
- wearing hand-me-downs
- being wrong in answering a question
- making a mistake
- competing with others
- being different
- not being successful
- "people finding out something about me that I don't want them to know, e.g., that I'm not a very nice person"
- poverty
- not feeling like a participant in life
- sickness
- sexuality
- people
- emptiness
- animals
- rejection
- victimization, crime, rape
- anger and losing control
- not marrying
- never having a baby
- being loved or loving
- death and suffering

Many of us have realistic physical fears of being followed or watched which could lead to being robbed, attacked, or raped. It does not help our peace of mind to know friends who have had these experiences even if we have not. Single women are terrorized by the growing crime rate and the increase in rape. Experts feel that the violence we so often see on film instills fear in our subconscious minds.

Fear of Growing Old Alone. In a rap group recently, one of the women who is still in her fifties admitted that she is sometimes almost paralyzed from thoughts about what will happen to her when she has to retire. Her only relative, a distant cousin, is not close geographically or emotionally. She told us that her mind races like a roller coaster along questions such as "How will I manage if I get sick?" "Who will come to see me?" "Who will be there if I die?" Though there are long periods when she does not think such thoughts, when they recur, she says, the threat is so great that she feels weakened and depressed. Other women worry about how they will buy groceries, handle their laundry, clean their home, get to the doctor, and maintain relationships.

The best way to overcome some of these fears is by using a rational approach. Make a list of possibilities you fear, and how you might overcome them, and what your alternatives are. Begin early to look into possibilities for retirement. Take a course on retiring. Use your willpower, activate your self-discipline, and quit worrying! In John 14, Jesus tells us, "Let not your hearts be troubled." He does not ask the disciples to talk about their worries, which he knew quite well would increase them, but to quit thinking about them. He turned the disciples' thoughts to the fact that God has prepared a place for each one of us and is ready to help us when we have faith. All we can achieve through worry and self-pity are

feelings of helplessness and hopelessness. Therapists know that fears and worries that are not reinforced will eventually go away.

Fear of Death. The older a woman becomes the more likely she is to be troubled by a fear of death. The worst aspects of this fear seem to be not in knowing when or how it will come but that it is inevitable. We are especially prone to this fear if we have watched a loved one suffer or had a child die in our arms.

One way to prevent this fear from becoming obsessive is to live each day as though it were our last. We can make the most of every moment, savor it, enjoy it, be grateful when we go to sleep at night and when we awake in the morning. When the time comes for dying, for giving up our dreams, possibly feeling helpless and dependent, we should accept death as part of a normal life.

Other Fears. Over and over again in leading retreats and convening classes I have found that the greatest barrier to good relationships is the fear of rejection. Just as it is true that "perfect love casts out fear," so also fear casts out love.

Fear is caused by a disturbance of love—inhibitions in the giving and receiving of love. The symptoms are the same as for loneliness: alienation, hurt, deprivation, rage, jealousy, guilt, depression. This is true whether the disruption is due to death, separation, or emotional blocks within the individual. Inner blocks lead not only to anger but also to guilt which prevents intimacy and good relationships by breeding low self-esteem and self-alienation. As fear and guilt increase, they perpetuate a vicious cycle: the person begins to build interpersonal walls, more anger and guilt accumulate behind the walls, and the walls must grow higher and thicker.

Another problem is the fear of opening oneself to others and the consequences. Those who spend their time and energy avoiding being known, concealing their real selves, become blind to others. They are so wary that they often make assumptions that are false. A woman who seeks love without openness and honesty usually falls into patterns of blaming, avoiding, preaching, placating. Because she is afraid to look at her responsibility in creating a bad relationship, she tends to blame someone or something else. Then she either wants to avoid the person or preach to that person to see it her way. When she sees that things are getting worse she may withdraw altogether or will try placating, even though she still feels angry and rejected. Because she fears change and conflict, she forms these self-destructive habits.

Anxiety and Fear. Of course, not all fear is bad, although if often feels that way. The instinct of self-preservation in the face of the unknown protects us from harm. Any fear that produces a healthy caution in us is a good fear. It saves us on countless occasions from physical harm and from making wrong decisions. Healthy fear is a temporary state of mind. As such it is nothing to be ashamed of. Fear is bad only when it becomes a ruling passion, when we find ourselves victims of fear with no control over it.

I have seen fear paralyze otherwise strong women, causing confusion and conflict which weakens the personality. I have counseled women who are fearful of everything in life after having lived with a battering or otherwise fear-inspiring person. One such counselee listed more than two hundred specific fears that plagued her. She was living a life of real hell.

Such fear destroys inner unity, upsets physical health, paralyzes the will, and destroys one's emotions of love and tenderness. One woman put it this way: "I am not

afraid to live alone, I am not afraid to drive distances, and I'm very capable of supporting myself financially. Despite this, this feeling of overwhelming fear resides with me now."

In healthy fear we are aware of what threatens us, we are energized by the situation, our perceptions are sharpened, and we flee or overcome the danger in appropriate ways.

In anxiety we perceive the threat but we are not clear what steps we can take to meet the danger. Our perceptions generally become blurred, we feel panicky, we may feel faint or hollow in the pit of the stomach. Anxiety is feeling overwhelmed, confused, unable to cope.

Some Solutions. Fear will never obsess us or rule our lives if we develop habits of mind that will put trust in the place of fear.

Some of the approaches you need to develop are the following: (1) Regard fear for what it should be, a gift given to you for a purpose. (2) Develop a curiosity about what motivates your emotions. Do not be afraid to discover the truth which will set you free. (3) Do not fight the fear but rather fight that which makes you afraid. (4) Practice self-discipline: be strict with yourself. Examine the fear before trying to put it out of mind. Then remember that you do not have to think about anything you do not want to think about. Substitute some other thought or reaction: humor, the resolve to fight, doing or facing what you are afraid of. (5) Take relaxation exercises, swim, jog. (6) Develop faith and trust, read devotional material, pray. (7) Make up your mind to live a new life and stick to it.

CHAPTER 4

Meeting Our Needs

Single women have the same needs common to all human beings. First there are the basic needs for a life-supporting environment: sustenance (air, food, water), clothing, and shelter. Next are needs for self-respect, love, and worthwhile activity.

Many people are not aware of how many things they actually need in order to make life complete. We often spend an inordinate amount of time on a few of our needs rather than seeking to satisfy a wider range. Here is a list of a few of our many needs:

> Personal relationships with people of both sexes and all ages, including the ability to forgive and repair broken relationships and to respect others' needs for privacy and solitude
>
> Freedom to develop relationships, and a balance between dependence, independence, and interdependence
>
> Love, in times of grief, loneliness, sacrifice (not martyrdom); tenderness, caring, touch, and sensitivity
>
> Meaningful goals to work toward and freedom to develop the self in relation to these goals

- Self-discipline as well as feedback and cooperation from others to aid in maintaining the goals
- Protection from assault through peace and justice
- Stability and order
- Freedom to speak out against oppression whether in the family, community, or nation
- A stable state of equilibrium both biologically and psychically, including meditation, contemplation, tranquillity, musing
- The creative use of our entire energy system (physical, psychic, rational, sensual, spiritual)
- Yearning, longing, a challenge to expand our horizons and spur our imaginations
- Nurture of this spirit in wonder, worship, awe before the spiritual which may be beyond our understanding
- Stimulation, play, fun, joy, merriment, celebration, praise, gratitude, contest, and experience: both bodily and mystic
- Humor, appreciation of the comic and the absurd
- Truth, honesty, simplicity
- Wholeness, unity, integration, a tendency to oneness
- Aliveness, process, flowing, expressing oneself
- Hope, through faith and trust in self, in one or two others, and in God

Nevertheless there are needs which many women meet through marriage that single women must plan to satisfy through other channels. These include the need of the single woman to express her sexuality, the need to have supportive relationships, the need for a pleasant home, and the need for economic security. Often those outside a marriage partnership forget that these needs are seldom perfectly satisfied by one person—even in a good marriage. The wise woman, married or single, does well to look for help in many directions.

SEXUALITY

Sexual relations and sexuality are not the same thing, but the two are often confused in our minds and actions. Sexuality involves the totality of our being: body, mind, feelings, spirituality, sensuality, dreams, and attitudes about our own bodies and those of others.

On the other hand, sex is a biological urge oriented toward pleasure, tension release, and sometimes procreation. Sex is aimed at genital activity culminating in orgasm.

Our times are preoccupied with sex, and cues from all sides keep many women insecure about their sexual lives. One of the most confusing—and incorrect—common beliefs is that women need regular sexual intercourse to be healthy, normal people. Many doctors agree we can be wholesome, fully developed human beings without orgasmic sexual relations. We can accept and express our sexuality as women in various other ways. Many single women in other eras, and nuns in our own time, have lived happy and healthy lives without genital sex. Many have found contentment through celibacy— directing sexual energies into various constructive channels. Such well-used energies can be utilized with great creativity in artistic work, in helping others, and in supporting a rich range of feelings.

Yet how can we choose wisely to find our own individual ways to express sexuality? The first and most important step is to acknowledge and accept the fact that we are sexual beings. God made sexuality a vital part of our lives. Some religious people would like to deny altogether that they have sexual needs, not recognizing God's intention that these energies be used for joy and deep human satisfaction. Second, each individual must look carefully at personal needs and wants in order to find out

how best to express them. We often have conflicting wishes and desires in sexual matters, and sorting them out is very important. Such examination will help to avoid unrealistic hopes for a magical answer to our needs. We have all been badly served by romantic stories that end with "happily ever after."

Biblical Principles. In discussing options for expressing sexuality we will be guided by three biblically based principles. First, Paul begins his exploration of sexual morality for Christians when he says, " 'All things are lawful for me,' but not all things are helpful" (I Cor. 6:12). This statement implies great freedom, but also self-restraint in choosing only actions that are "helpful." Second, further light is cast on the notion of what is "helpful" by the biblical principle of shalom, which includes peaceful well-being, and health for oneself and others. God wants us to be whole and healthy and to nurture these qualities in others. Third, the Bible has a good deal to say about human duties, loyalties, and responsibilities. For example, "You shall not commit adultery" emphasizes the importance of loyalty to a marriage partner. Such ethical rules are based on age-old experience in maintaining a healthy system of human relationships. Living up to our duties, loyalties, and responsibilities toward self, family, friends, those entrusted to our professional care, and our neighbors, local and worldwide, is vital in choosing what is "helpful" for expressing our sexuality.

Our needs for sexual satisfaction are both physical and emotional. We will discuss emotional relationships in the following section and emphasize physical sexuality here. Physically, most adult women experience bodily tension and longing for the release of this tension through intimacy with another person. These feelings are based partly on body chemistry, part of nature's plan

to continue our species by having children. At the same time, human females have a wide range of times when they experience sexual feelings, which may be satisfied in a variety of ways. Some of the ways of dealing with physical needs can be listed here. Most of these are reciprocal—involving both giving and receiving.

1. *Touching and Stroking.* Most of us enjoy giving and receiving pats and strokes. As with other species, we like skin sensations such as those caused by brushing our hair, getting a backrub, or taking a shower. Some people satisfy the need for touch by holding and patting pets.

2. *Symbolic Skin Contacts.* Hugging, kissing, handshaking all suggest warmth of feeling as well as the satisfaction of stroking. Social circumstances determine whether we feel such actions are right with a particular person at a particular time. Some women may worry about lesbian implications in receiving physical affection from other women or may be reminded of deeper intimacies that they lack. Nevertheless, affectionate contact is most often very pleasant and need not communicate a wish for more explicitly sexual expression. Some reservations about affectionate contact may be unrealistic, and we should learn to use this kind of communication generously. At the same time, we should be careful not to use gestures as a substitute for deeper relationships.

3. *Masturbation.* While some religious people experience guilt for this very common practice of arousing one's own body to the point of orgasm, it might well be a constructive option for the release of sexual tension. One woman I counseled felt a sense of freedom after masturbation because she was strongly attracted to a man already happily married to another person. Another woman felt that masturbation enabled her to know and enjoy her own body better. In religious terms, God is concerned with respecting loyalty and encouraging full acceptance of oneself.

4. *Sexual Relationships.* This is not the place for discussion of the infinite variety of techniques for the arousal by another to the point of orgasm and the reciprocal giving of pleasure. Many people find this the best way of satisfying sexual needs, particularly when the partner is deeply loved in a long-standing, caring relationship. While there can be no doubt that intercourse with a relative stranger can be physically pleasurable, the best religious and medical authorities recommend intercourse as part of a loving relationship. Sex within a committed, caring marriage remains a standard and model. There are, of course, different degrees of commitment in loving relationships outside marriage. Since single people are by definition not married, let us look at some other patterns of relationships.

 a. Committed couple—man and woman. Many people are choosing to live together and share their bed as part of a wish to share their lives, at least for a while. The woman and the man have a chance to increase their knowledge of both self and other, with great opportunities for growth. They may have children and enjoy the pleasure of sexual intercourse with a loved and trusted person. Disadvantages of this arrangement are limitations on one's time and independence, and increased risk of separation where no formal promise of commitment and responsibility is given.

 b. Committed couple—woman and woman. There are conflicting messages from the Bible concerning the love for someone of one's own sex. Yet some women feel that being attracted primarily to other women is one of their inborn characteristics. Some women feel that full sexual expression is appropriate within a deeply felt loving relationship with a particular other woman. While tolerance of homosexual couples is slowly growing, there continues to be much social disapproval. Women who love one another sexually risk guilt and censure. Never-

theless a considerable number of unmarried women have experienced growth and lasting satisfaction through intimate relations with other women.

c. Steady couple. Many couples, heterosexual and homosexual, share sexual relations as part of a deep ongoing friendship, although they may see one another only at intervals.

d. Casual couple. Recently many single people have sought sexual satisfaction with partners they do not know well. Such relationships usually lack caring and concern, and may lead to confusion about true intimacy, which is essentially a meeting of whole persons, not just their bodies. Furthermore, there are risks of disease and emotional damage.

Other types of sexual relationships are clearly not "helpful," such as spouse-sharing, concealed adultery, and group sex. Furthermore, sexual intercourse may be a form of violation, as in rape or incest.

Every woman should respect her sexuality whether sex is involved or not. Here are some suggestions for feeling physically well:

> Get plenty of physical exercise, preferably vigorous and regular. Do sports, jog, or at least take a brisk walk each day.
> Stay in good general health, get proper rest and food.
> Maintain interest in a variety of activities and people.
> Treat yourself well, with good grooming and pleasant, fresh clothes. There is a kind of beauty at every age—enjoy being your most attractive self.
> Develop supportive friendships with people you trust. When sexual feelings become involved, discuss them and make a joint decision about how to handle them.

RELATIONSHIPS

A single woman has the chance to choose a rich pattern of relationships. Although her blood relatives and school friends may be busy or far away, she can form families from people available as friends. She can pick congenial people of various ages, men and women. One woman in her thirties who moved to a strange city for a new job has now "adopted" a grandfather, a mother, a father, two brothers, three sisters, an intimate male friend, and three children. These she met at work, at church, in her neighborhood, and through friends elsewhere. Whether close or casual, friends can be sought and kept through discernible patterns, which we will examine first. Then we will look at possibilities for relationships through groups and through organizing a professional network of "contact" people.

Friendships. Developing friendly relationships with both men and women is very important. The importance of friendship cannot be overemphasized. But there are difficulties for the single woman. One woman reports: "I've found that a single woman has trouble with close friendships. If I am very friendly with another woman my age, everybody suspects us of being homosexual. If I am very friendly with men my age, the inference is that I want to get married. If I'm very friendly with married couples, I am sometimes seen as a threat by the wife. Where can I find a warm, personal relationship?" Despite such difficulties in forming meaningful friendships in our society, it is essential that we try.

A divorced friend said: "Friends have helped give my life continuity and meaning. I'm not sure whether the jagged edges, the stops and starts and jumps, could make sense to me otherwise. Friends have given me courage at

times when I've felt down and alone, and support when I've tackled challenges. Since my divorce, I have found it easier to make friends. Although I've been more alone, I feel less lonely."

Another woman wrote this: "If we define a friend as one who helps us to be our very best self, then we must begin by being our own best friend. We must recognize our strengths and that they are worth using and developing. We must be compassionate with ourselves about our needs. As with every friend, we have to know ourselves and be good to ourselves.

"Next we will look to others for friendship. We must not only choose thoughtfully but remember not to reject carelessly. Friends may be waiting in unlikely places. If I am single and middle-aged, I need not limit friendship to other single and middle-aged people. Friends may be married, much younger or much older, with similar backgrounds or from very different areas of life. If we share an interest, give each other new perspectives, are *simpatico*, we can become true friends."

Friendships affect our love relationships, and vice versa. Distinctions between friends and lovers are becoming blurred among some single people, and relationships can often move back and forth between the two. Looking at how love and sex influence friendship can help us grow in our relationship awareness.

There may be times when an honest commitment to growth means having to terminate nongrowing friendships. This can be done without blame or guilt by viewing unfulfilling relationships as already dead, with their ending perceived as an opportunity rather than a failure. Saying good-by can be as important as saying hello, as an affirmation that life is temporary and only what is really alive is best for both parties.

On the other hand, there is the importance of commitment to one or more people. Through commitment we

learn to know ourselves more deeply even though more painfully. Commitment can free us in ways that moving from friend to friend or lover to lover cannot.

Most friends have an underlying unity of purpose: fidelity toward each other, openness with discretion, willingness to know and to be known. True friends who have come to trust each other can speak the hard truth in love, and that trust is built through the ability to keep confidences. The deeper the friendship, the more wonder, awe, respect, and reverence each has for the other's uniqueness. We understand that we can know the other only partially, for "knowing all" is a form of possession. Recognition of the distance between us is vital to a deep and permanent relationship. The ideal friendship balances the creative tension between separation and unity which is essential to the growth of each individual as well as of the relationship. Recognizing the other as God's creation endows the relationship with freedom.

How can you yourself become a friend?

> Be honest. Do not pretend or try to be something that is not natural to you.
>
> Show interest in the other person. Do not center a conversation on yourself all the time. Listening to others, hearing, and responding make one a very interesting person. If you want people to be interested in you, you need to be interested in them.
>
> Let the past go, especially if it is painful. Unless you do, you may not see the potential good in the present moment.
>
> Learn from your mistakes and try not to make them again.
>
> Risk being vulnerable. If you close yourself off, all honest interaction with another person will cease.
>
> Take responsibility yourself for what you do and feel. If you are angry or bored, recognize it, admit

it, do something about it. Appreciate, affirm, and encourage your friend. Above all, enjoy each other.

How are friendships destroyed? Most dramatically by rejection, angry words, too much emotion. Friends sometimes drift apart or one grows away from the other when what brought them together is outlived. Being possessive or afraid of being possessed, being jealous or demanding puts a friend on guard. Being too rational is hard on many male-female friendships, as are attempts to manipulate through shyness, hurt feelings, unforgiving attitudes, hostility, or refusal to forget the past.

Developing friendships is important to our well-being because relationships to which we are committed challenge us to: (1) discover new things about ourselves and other people or *this* person, our friend; (2) see things from new perspectives and understandings. To have a friend is to know we are worth something to another person.

Most women find relationships through groups they can join for a number of reasons: support, exercise, sports, fun, education, job opportunities, political action, sociability, and social climbing.

Special Relationships with Men. While much that has been said about friendship applies to both women and men, yet relationships with men deserve special discussion. Fortunately, nonsexual friendly relationships between men and women are more easily formed today than in the past. The growing equality of women has offered many opportunities for relationships outside traditional patterns of courtship.

Yet many of us will want to seek out men for romantic attachments as well. If this is a goal for you, the following guidelines may be useful in preparing yourself, finding a potential mate, and developing good relationships.

1. Develop yourself.
 a. Be faithful to who you are. Do not play games, wear masks, or be false or phony.
 b. Pursue activities that interest you.
 c. Be an interesting person by involving yourself in a variety of activities.
 d. Travel the life course that is natural for you. Find your satisfaction in serving others and reaching out to others whether a man is involved or not.
 e. Develop yourself to become a full person in your own right who does not need to look to a man for identity.
 f. Consider your priorities. Go on living your life in a way that is comfortable for you, pursuing areas of interest and being open to meeting men who share those interests. At all costs, avoid going on a frenzied manhunt, stalking the singles bars looking for a lifetime companion.
2. Meet potential mates.
 a. Do *not* stay at home.
 b. Pursue areas of interest: the arts, study, sports.
 c. Entertain single friends and couples. At their parties you meet others.
 d. In extremes choose job, career, location, where there are more men than women.
3. Develop good relationships.
 a. Try to develop a friendship before a lover's relationship.
 b. Establish open and honest communication from the start of any relationship.
 c. Look for the type of man and relationship you want over your lifetime, not what society is holding up as its latest male idol.

Women's Groups. Today the women's movement is quite sizable, very fluid, and is working at all levels of society. It rose to prominence largely because a few women were no longer willing to accept their lack of power and inequality in a male-dominated culture. Many of these women were justifiably angry. Some women may not identify themselves with this movement but nonetheless desire its benefits: equal pay for equal work, justice under the law, equality of opportunity, and the defeat of sex discrimination in all areas of life.

It is important to pick women's groups according to your interests. Many of them have contributed to changes in the status of women. Each woman is needed, since plurality gives breadth and depth to the movement toward liberty, justice, and equality for all.

No group can be effective if the members are not willing to be full participants. We get out of a group what we put into it. A group made up largely of takers and few givers is bound to have a short life.

Some women's groups are national organizations, such as the Older Women's League (OWL), National Organization for Women (NOW), Daughters of Sarah, the Evangelical Women's Caucus, Women Against Pornography, and Women Against Rape. Others are small local rap groups, consciousness-raising groups, self-help groups which address any problem a woman might face. There are groups for exercise, sociability, fun, and sports. The YWCA and exercise salons not only are good for mind and body but may lead to socializing and friendship.

Some women's groups are militant, bitter, negative, and angry, tending to be selfish, self-alienated, and ingrown. Greater creativity is engendered in those women who refuse to use their energies in destructive—thus self-destructive—ways.

The solutions: (1) develop genuine friendship and (2)

seek out groups with a cause that you approve of and want to support.

Mixed Groups. Being the only single woman at a dinner party can be devastating. Only gracious, sensitive married couples can make a single feel that she truly belongs. Yet it is important to overcome the difficulties and take advantage of such invitations for a variety of reasons: (1) To show that single women are not elitists and are eager to be included in a larger family; (2) because both single women and married couples benefit from the interchange; and (3) to help break down the myth that single women only go where there is a possibility of finding a man.

Cocktail parties, wine and cheese parties, and open house parties tend to be more casual. A young woman who has attended many in the years since her divorce said recently: "I'm no longer interested in the games and phony posturing that go on at these gatherings. I've met some interesting people, it's true. These parties have filled many a lonely night. But that is no longer enough for me. More than anything else I want a warm, open, honest relationship with someone who appreciates me for my mind as well as for my body."

Mixed singles groups are so varied and numerous, I suggest finding a good singles magazine which lists the activities in your area. Some churches, particularly the Unitarian, sponsor wholesome singles groups.

As for relationships in the work world, there is still much discrimination. My advice is to form, very carefully, personal alliances with both men and women for support and power. There is no longer reason to be a victim of either discrimination or sexual harassment. There are many legal avenues and organizations, such as Equal Employment Opportunity and Affirmative Action, which may be called on in the case of discrimination.

A woman should avoid confiding in a fellow worker on short acquaintance. She may discover a few months or years later that her confidence has been betrayed to damage her reputation and thus her advancement in the company.

Networking. Networking is getting to know the right people in order to accomplish goals on the job, in a profession, or for a cause. These personal contacts offer support, information, on doing business or getting a job done. Networking can be a form of consciousness-raising for those who need advice or help on business matters. The only requirement is that a person should give help as well as receive it.

A woman must decide whether her goal is fame, money, power, or service and make her plans accordingly, choosing her contacts carefully. There must be a basic integrity and trust between her and the contacts she cultivates. It is essential for her to use her time well, be discriminating, and remember that in networking it is better to be respected than to be liked.

The skills of networking can easily be used in areas of individual interest. Seven years ago a friend and I began a network for women working with women. We did not want important issues for women to fall between the cracks, nor did we want to spin our wheels duplicating work that others were doing. We contacted women from many types of work: recreation, housing, law, pretrial services, battered women's hot lines, women's centers, the YWCA, churches, women's training programs, colleges, family life programs, and more. We encouraged the women to share resources, brochures, bibliographies, names and addresses for the network mailing list, and anything else they felt would be helpful. During the months we met, we were a source of support to one another and to our organizations.

Every woman has an existing network to begin with: colleagues and co-workers, the networks of parents and other relatives, neighbors, teachers, fellow members of clubs, school friends—all of whom have networks of their own.

Church Groups. Even though single people make up one third of the adult population of the United States, many churches still show little interest in singles between the ages of thirty and fifty-five years.

Yet churches might be places that single women could use for networking and for activities. We know from our work at the Women's Center that there are many women who have "done the singles scene" and want to try something else. That "something else" might include social events (such as lectures, casual get-togethers, tours), community service work, or a study-social group (such as Bible study or prayer combined with a social hour). If you know one or two single women who feel this way, try to find others and start a group of your own.

We are capable of community, of choosing a new family. As we participate in group life, providing a measure of genuine closeness with a few, the honest communication of feeling and thought between the people involved begins to release individual aptitudes into creativity. As we plan and work, cooperate and pray together to make decisions, we are enriched with a sense of security and worth which comes from accepting and being accepted by our brothers and sisters. In genuine community the self feels enhanced and stronger. Tenderness toward and enjoyment of self, of one another, and of God grows in such an atmosphere. It is worth taking risks to achieve such a life-style.

A HOME

The first requisite for a home is that we like and are comfortable with ourselves. A good feeling about oneself helps develop an environment that also feels good. We cannot expect to have a real home with someone else or in a community unless we can make a home for ourselves first.

It is important for every woman to have a space which is hers alone in order for her to fulfill the need for solitude and contemplation as well as to enjoy and entertain friends. Her surroundings need not be extravagant or spacious if they somehow reflect her personality. One of the places I enjoyed most in my life was a small room in which I used orange crates covered with pretty shawls for tables, bricks and boards for shelves, a mattress on the floor for a bed-couch, and bright throw pillows for my guests to sit on. In that cozy place, which I had made my own, there was much laughter and merriment.

Many single women I know, feeling that their singleness is a transient situation, do not develop roots or a place in which they are comfortable and at home. It is true that a person who feels at home within herself can feel at home in most any environment.

If a woman is in transition, she is temporarily disoriented from her own peaceful inner center. Her self-image and self-respect are often at their lowest ebb. A woman who feels messy on the inside will probably live in messy quarters and eat poorly. She will not want to entertain friends or feel worthy of being entertained.

Improving her physical health and surroundings can help to improve and stabilize her self-image. As she overcomes her inner turmoil and adjusts to the realities of her situation, her home will begin to reflect the

stability she feels and the self-respect she acquires.

Women who feel good about themselves are generally presentable, clean, and orderly. They care for their environment in the same way and enjoy sharing it with their friends. Of course, there are women who pay undue attention to outward appearances which may be as neurotic as not caring and connotes equally poor self-esteem.

A friend said recently: "It's important for me to have my own things around me. I move around a lot in my job, but I carry a few things with me that identify even a hotel room as mine. A few significant or colorful objects make me feel good."

Even when the room is furnished or filled with cast-offs, a few well-chosen accessories can personalize that which is strictly functional or possibly even ugly. It is important for one's well-being to develop an atmosphere that feels warm, full of vitality, and is peaceful. Plants, curtains, lighting, comfortable pillows, or something a woman made herself can all make a difference. Use your imagination and follow your instincts. But whatever you do, enjoy yourself.

Living arrangements. A single woman may choose among or be forced into a variety of living arrangements. Some choices she might make are:

> living alone
> living alone as celibate
> living alone, having sexual relationships outside
> living with roommate(s) as celibate
> living with a lover
> living with parents or with other relatives
> having parents or other relatives live in her home
> living with her grown children in their home
> having children live with her in her home

group living: nonreligious institutional or private (shared housing)
group living: religious

A good exercise for any woman who needs to make new choices is to study these alternatives. List the advantages and disadvantages of each option. Discard what seems inappropriate. Make new lists of advantages and disadvantages for the two or three alternatives that remain. Continue to work on this exercise over a period of several months while exploring concrete possibilities. Gradually the best options will emerge if you plan carefully.

ECONOMIC SECURITY

I personally began to feel more financially secure when I became self-confident and sure within myself of my worth in the eyes of God. However, even with such assurance, finances can be most difficult. Women are generally poorly paid. The single woman too often does not address herself seriously to advancement and retirement, seeming to hope that her self-supporting status is temporary and that she does not have to plan ahead.

These are things she could do:

1. Learn to save in small ways. Women who come to the Women's Center tease me about being a miser when they observe the way I save plastic bags, plastic cartons, every bit of leftover food (which *does* get eaten), everything. I know that I have saved thousands of dollars through the years in these small ways. Many people are extravagant and wasteful. Even those who have low salaries, who find it difficult to make ends meet, and who are often in debt, somehow think it is demeaning to be frugal and saving. There are excellent books available that can help in this regard. Read one and put the insights to work.

2. Learn to live with others. Sharing an apartment or a house means saving on large appliances, utilities, furniture, food, and sometimes a car.

3. Establish a good credit rating by paying bills on time. An apartment, utilities, and insurance policies all in your own name are good ways of establishing credit.

4. Be meticulous about managing your money. Do not get into trouble with the Internal Revenue Service. Take courses in planned spending, in planned investment, and on retirement. Consider long-range investments that will produce higher returns.

5. Insure your employability and opportunities for advancement by upgrading your skills, learning new ones, and taking advantage of continuing education in all fields. Or combine a number of your interests and talents to start a business of your own. There are many such ventures to enter into. A few of them are:

 catering

 housecleaning services

 shopping service for people who find it difficult to shop, such as the elderly, the invalid, working women with families

 typing services

 freelance work of many kinds: writing, interviewing, advertising, editing, accounting

 interior decorating

 needlework shop/handmade garments

 dressmaking and alterations

 antique or craft shop

6. Be sure you are well covered by insurance, since, as a single woman, you probably have no one to fall back on in the event of illness or disability. Check benefits carefully for discrimination. For example, some group insurance policies cover spouses of male employees but not of female employees. Single women in large companies often pay for unnecessary life insurance policies.

There are many other factors to watch. Read the fine print.

7. Investigate pension plans. If you work for an organization that has one, check on the vesting requirements of that plan. If your company has no such plan, investigate various types of plans before making a decision. Today there are a bewildering number of different kinds to choose from. Sometimes, for one reason or another, it is more advantageous to have your own plan rather than a company plan. Consult your banker or other financial adviser for help in choosing the best option.

Your feelings about money and time have profound effects upon how you decide to use your time, talents, and energy. Dee Dee Ahern speaks well about these issues in *The Economics of Being a Woman*.

The earnings of women are roughly 40 percent below those of men. The recent large number of female entrants into the labor force has undoubtedly tended to sustain, if not widen, the income differential. But counterinfluences are at work: The women's liberation movement has played a positive role in publicizing discriminatory treatment of women in the work force. The Civil Rights Act of 1964 prohibits discrimination on the basis of sex (as well as of race, religion, and ethnic background). On the other hand, there is much work to be done if women are to retain the progress made during the past decade.

Since economic security is never totally assured, do not sacrifice your dreams or visions of work in service to others, though poorly paid, in order to obtain or keep a job for financial security alone. Inner security of liking and caring for ourselves rests on the harmony between our life and our work. Some of the most fulfilled people in the world are those who have attained that balance.

CHAPTER 5

Opportunities for Single Women

Because they have fewer ties than married women, single women have a wider range of opportunities. In this chapter we will explore how to use creatively our chances for freedom, self-determination, self-development, and involvement with others.

FREEDOM

I always ask singles who attend workshops and retreats, "What do you like most about being single?" Almost without exception the answer is freedom. Specifically they have said: "I can schedule my time as I choose." "I have fewer chores to do." "I don't have to please anybody but myself." "I can have *friendships* with men. I'm freer to explore various kinds of relationships with people." "Freedom to travel is my joy."

One widow said: "There are many things about my new life that I like. I can come and go as I please, without checking out if it's okay with anyone else. So, there are some joys, but I wish I could have enjoyed them without the death of my husband."

A divorced woman remarked: "It's like a fresh wind

blowing to be free. I've never had so much fun. I go where I want to, see the people I feel like seeing, read late, awaken early, sing loudly in the shower. No one yells at me to be quiet or demeans my behavior. Right now everything's coming up roses."

An interesting idea came from a woman who said: "I think that to stay single is a luxury. When you have a mate or children, you have to compromise. When alone, you don't have to compromise—you can choose your own schedule. In the long run this may cause problems if too many in our culture live in an egocentric way. However, personally, I enjoy the luxury of being single."

Living autonomously does not necessarily mean living in loneliness. The privacy one has allows time to experience innermost thoughts, take a walk, listen to music, pray, meditate, contemplate, to be wholly oneself. One has the space in which to find the strength to become a lively and creative person.

On the other hand, freedom is an awesome and precious gift, to be received with care and handled with thoughtfulness and love. Mark Twain has been quoted as saying, "It is by the goodness of God that in our country we have those three unspeakably precious things: freedom of speech, freedom of conscience, and the prudence never to practice either of them."

Whether or not they take advantage of it, many single women have greater freedom to use their time and money for study and training, not only toward a career but for personal betterment and self-awareness.

A single woman's freedom can also open up the possibility of developing qualities of friendliness and enthusiasm for and affirmation of life. She has no husband who demands a quiet evening at home, and probably no children requiring her attention. She is free to be interested in everything and to share her excitement in

life with others. She is free to give her time and sympathy to a friend in crisis, and to give her friendship to the lonely. Giving of herself by reaching out to others to brighten their day can help alleviate her own occasional pangs of loneliness.

A woman recently widowed told me: "It's a new world for me but I feel I can manage. I realize I must reach out, not only to receive but also to give, and I'm doing that. I am rather self-centered these days and I don't like that, but I am aware of the problem and will see to it that this does not become a way of life.

"I don't think life as a single woman is formidable, it is a challenge. It will increase my self-sufficiency and independence. I have many plans and dreams and I intend to pursue them."

Each of us has special gifts, special abilities which we can use in the service of God and other people. Our potential is so great in this regard that Jesus was bold to say to the disciples, when they were questioning him about his death, "Truly, truly, I say to you, the person who believes in me will also do the works that I do" (John 14:12).

In his great letter to the Corinthians, Paul assumes that each Christian will receive a gift from the Spirit designed, not for the individual, but for the good of the whole—to produce unity in the body (I Cor. 12:4–29). These gifts are many and varied: wisdom, knowledge, ability to preach or teach, faith, healing power, prophecy, discernment. This implies, of course, that anything you can do that serves another person is a gift of power from God. We can choose what we will do with our gifts. If we choose to use our gifts and potential, they grow in power and usefulness. If we hide them, fail to use them, ignore them, or deny them, we can become impotent, unhappy, anxious persons.

SELF-DETERMINATION

If the single woman is free from family responsibility and criticism, what is she free for? She is free to live her life selfishly, aimlessly, unaware of its great possibilities, or she is free to share herself in love to those around her. Love does not resist change; it welcomes expanding awareness. Love says, "Start right where you are." The single woman does not need large amounts of money, political power, stunning physical beauty, great intellect, or any other extraordinary attribute to find an opportunity to use the gifts of love. She is free to move from bondage to freedom, from anguish to joy, from darkness to light, from subjection to redemption, from mourning to celebration. All she needs is the wish to reach out and the willingness to learn and to risk.

It is a known fact that few people have learned to tap their potential. Most use about ten percent of the power and gifts that are theirs. Those who do not develop their interests and use their talents are neither responsible nor free. Instead, they may be angry and fearful, wondering who they are and what purpose their life has. They may allow emotions to rule them rather than taking charge of them.

It has become clear to me in the past few years that feelings are entirely unpredictable and unreliable. If we succumb to the negative ones, they can cast us into the darkness of depression and despair, cause us to feel helpless and hopeless. People judge us by our actions, our behavior, which we can control. More often than not we can change negative feelings and emotions by acting and thinking in ways that are life-giving, by responding creatively to the frustrating situations that are a part of life. If we feel helpless and do nothing constructive, those feelings lead to hopelessness. But if we refuse to

give in and set our minds to look at alternatives, we can usually find a way out of our dilemma. The more we choose behavior that is successful in overcoming boredom, fear, feelings of failure, and helplessness, and avoid giving in to destructive feelings, the stronger and happier we become.

A divorced woman recently wrote: "During the last fifteen years, I've come to realize that women have power. In the past I thought power was something only men possessed, and only bossy, aggressive women would ever think of using power. Now I like to think of power—my power—as energy which I can choose how to use. When I'm deciding how, when, and where to use my power or energy, I do the following: (1) I take a moment to *realize* I can use my energy negatively or positively in almost any situation. (2) I get *in touch* with my options. There are more than there appear to be at first. It's fun to think them up—be creative! (3) Then I *choose:* not choosing is a choice, you know, but then you've given up your power. Happily, most of the time I choose positively. You can too! Choosing how, when, and where to use your energy is a gift from life."

It is a paradox that in some areas single women are both more free and more dependent than married women. For example, a single woman who is totally responsible for herself may have great fears about her economic security which keep her from taking risks. However, without dependents she is free to take risks and become involved in ways impossible for a married woman. She might work for justice within her job, risking her salary from that job, not because she is wealthy, but because she is free from responsibility to others. She can take a chance for something important she believes in. She can more readily give up a career to serve the needy or to study. If she gives all her money to the poor, there is no fear that husband or children will suffer. She is free to

travel. She may work at jobs that use her gifts and talents in out-of-the-ordinary ways.

Many women tell me they are too tired when they get home from a day at work to do anything but go to bed. My own experience is that fatigue is due more to boredom than to hard work. Since the single woman is the person most often alone, she has the rare opportunity to discover deep meaning in "giving up her life." As she gives, she discovers that she finds treasures in relationships and new energy.

I can hear my readers saying: "Easy for her to suggest. She doesn't have an institutionalized mother to care for and support," or "a dying father," or "a handicapped child." When we hear stories of heroism and valor it is all too easy to believe that the heroine is much stronger, more gifted, or more intelligent than we are. God understands what each of us can or cannot do. If we give a small amount of time each day, make a tiny effort in a disciplined manner, it will be appreciated as much as the total sacrifice of a saint. During these past twenty-three years of trying to live by this simple rule, I discovered that tiny steps grew quite easily into larger ones. When I was finally asked to take big risks, I was prepared. At that point I was *expected* to take the big step and believe that the Spirit of life would be sufficient for each day. I have come to believe that Christian women should be taught to expect and to enjoy the big surprises, the challenges that stretch us, the faith beyond faith of the tiny child who trusts the kind parent's guiding hand.

A woman alone has a great opportunity to develop the human and womanly virtues of being joyful in the face of whatever life brings, at peace in the present, and holding hope for the future. This is possible because she can give undivided attention (cf. I Cor. 7:34). In giving herself to a cause larger than herself and allowing the Spirit of Christ to become the most important single influence in her

life, she can replace her anger with love, her anxiety with peace, her depression with joy. She can sift out what is less important, putting first things first. In our confused and confusing world we need women who will help us focus on lasting values.

Day after day we are given the choice between life-giving thoughts, attitudes, actions or those which lead more and more to selfish negation of fullness. In fact, we do make choices, though often quite unconsciously. Every moment is a choice between living life fully, meaningfully, purposefully or drifting aimlessly through it without much conscious choice. The question Jesus poses to a person mired in self-pity is, "Do you want to be made whole?"

The decision is ours. The responsibility is ours.

SELF-DEVELOPMENT

What would you most like to be or to learn? Have you always wished to do ballet, become a gourmet cook, or read all of Shakespeare? As a single woman you may have time and energy that can be used to develop your mind, body, and soul. Skills that we learn can make our lives much more satisfying. I would recommend practicing some new activity regularly—particularly learning to use the mind well, to maintain a healthy body, and to grow in knowledge and love of God.

Developing thinking ability is particularly important. Recently one woman said, "Why should the single woman think any more clearly because she is single?" Another quickly retorted: "Because she has to take care of herself. She has a wider range of responsibilities than many married women." The issue goes deeper than that. The woman who is truly alone, without live-in partner or children, has the special privilege of fewer distractions, fewer infringements upon her thinking.

Few of us are ever really taught to think for ourselves in spite of the fact that the Bible instructs us to "let this mind be in you, which was also in Christ Jesus." What do we know of his mind? Jesus was never mentally lazy. He seemed to be fully conscious of the world around him, always thinking of ways to reach people in order to make his teaching relevant and understood; he was alert and full of energy. To have the mind of Christ would be to think unselfishly with humility before God, valuing others above oneself. He was as aware of the wisdom of his intuition as of his conscious perceptions.

Though some of us are slower than others, what counts is that we make the most of what we have been given. Our minds, like our bodies, must be developed and nurtured.

Developing one's mind can be the richest kind of adventure. I recall how excited I was when, after eighteen years away from school, I went to seminary. At first it was painful to open the dark room of my mind, but when I did, the blessed release of new thoughts, exciting vistas, fresh ideas, novel ideologies cleared the cobwebs. During those first weeks of joyful new life, my entire universe appeared to be bathed in light. Every tree and blade of grass seemed to have special significance, the faces of people glowed, the air had an unusual tingle of energy and refreshment. It was not just my mind that was expanding, but my entire being.

It was not that I had been living without exposure to ideas. I sometimes devoured as many as ten novels a week, went to movies, and listened to the radio. But they were escapes from the realities of life, allowing me to live on the surface. I read lightly, not studying or thinking deeply about anything. I had not used my mental powers, had not actually allowed my mind to be challenged.

Why are people so afraid to expose themselves to new thought? How could a woman *know* she did not like

Beethoven's Ninth Symphony if she had never listened to it? How does a woman *know* she cannot grasp the intricacies of politics if she has not studied the issues? How does a woman *know* she cannot make sense of her finances if she has made no effort to learn about them? How can she *know* that the Bible is irrelevant if she has not opened herself to its riches?

Much of the dilemma of human suffering would be cleared away if women were not so ignorant of God's nature. Ignorance only results in superstition, fear, false guilt, and a paralysis of will. God created our minds and has every right to expect us to use them in the most creative ways possible. When we do, we will find a path through our problems and stand firm in the certainty of our wisdom.

In our culture most women have not been taught to make full use of their minds, though this attitude is breaking under pressure from the women's movement. But many still consider it unfeminine to be highly educated, to be smarter or higher in rank than the men in their lives. We have such messages beamed at us in both blatant and subtle ways from the time we are born. We are trying to break the pattern, but it is so ingrained and internalized that it is psychologically painful to do so. Too often women rely on fathers, husbands, or brothers to make decisions for them, believing the stereotypes that men are more rational and less apt to be carried away by emotions.

When we deny women the use of their minds and men the use of their hearts, we divide human power and diminish the power of God. We need men and women who are equally strong in thinking as well as in loving, receptive as well as assertive.

Single women have the opportunity to contribute to a new humanity as they develop their full range of potenti-

alities. Here are some guidelines for choosing what part of yourself to develop. Answer the following questions for yourself and then do the exercise with a friend.

1. What am I doing with my strong points and special gifts?
2. What am I doing with the unique combination of physical, emotional, intellectual, and spiritual resources that is me?
3. What have I wanted to do all my life that I have not yet done?
4. What do people tell me I am good at? Am I unwilling to pursue their suggestions? If so, why?
5. What skills have I learned? Do they apply to any special gift?
6. What turns me on, makes me happy, gives me a glow? Do these same skills and gifts make others happy or help them in some way?

"I need fulfillment." "I need to find myself." "I need to discover my potential." These and similar ideas are the grist served to rap groups around our nation—to the mills for supposedly grinding out new identities, new roles, new excitements, new relationships, new lives. Yet there are many dangers in seeking fulfillment for oneself. Undue emphasis is put upon our chief idol—the self. We lose our sense of community and belonging, the ability to imagine that our actions have any consequence outside our own life. We forget that there is anything more important than our own fulfillment, our own happiness.

Everyone close to us is hurt. Children, members of the extended family, and friends are all excluded in our search for a quick and surface solution to all our problems. We want what we call "a meaningful relationship," but once whatever had been construed to be the "meaning" of the relationship is gone, so too is the "relation-

ship" itself, and we are back on the road searching.

After my own frantic search for self-fulfillment proved futile, I turned my energies toward the full use of my mind and creativity. I began to gain respect for myself, to have confidence in my abilities, to see myself as a woman of intelligence and beauty. The need for others to love me was replaced by my desire to love and care for others. I began reaching out rather than taking in, being open rather than expecting others to open to me, committing myself to things beyond myself. Selfish? No longer. Self-assured? Yes. And so, the fear and anger and emptiness and frustration were replaced by a sense of adventure and meaning. I began to see outside myself, to regain my lost sense of community, and to take responsibility for my actions as they affected others.

INVOLVEMENT WITH OTHERS

We have the exciting opportunity and responsibility of helping to shape a better world. Singleness may give us the impetus to work toward a better life for ourselves and for those who come after us. Any of us who have been faced with the inadequacies of our legal, religious, political, economic, or social systems know that those systems need vast improvement.

We have already broken new ground in many ways. When professional help was either inadequate or too expensive, we learned to help ourselves and to help one another through openness and sharing. We learned that the collective imagination could be powerful in our personal lives. Now we needed to put that power to work for the sake of the larger community. A great deal more can be done as women continue to be leaders in the fight for fairness.

1. *Sharing the Lessons Learned from Singleness.* The following are some suggestions of ways in which we can share with society in general the lessons learned from singleness:

a. Every institution in our society needs help in defining goals and clarifying values. Find other persons who are interested in similar issues, gather and study the facts, share, pray, and act. It could be in politics, religion, ecology, law, the extended family. What is needed is justice, and concerned, caring people to fight for it.

b. Help other women achieve realistic images of their identity and their destiny rather than those forced upon them. The single woman can help younger women, and men, to realize that friendship and communication are possible without an atmosphere of eroticism.

c. Share your stories of courage, how you have accepted responsibility for your own life in difficult circumstances. Tell about the power within individuals to cope instead of copping out, and possibly finding joy and happiness in the midst of pain and struggle. Inform others of the strength it takes to stand against stultifying mores and life-styles and to live out your own beliefs. We need to bombard the media with our desire to hear stories of courage, not of violence; of hope and life, rather than of death and destruction.

d. Tell the rest of society about experiments in living, such as the barter system, the extended family, and less complicated living. As single women are forced, out of economic necessity, to double up and share their resources, they can learn through new experiences what is enriching. Out of necessity they are learning that they can all get along with less than they thought they could. No one needs a new dress every time she goes out, or needs to go to an expensive place every weekend. In fact, what we are learning about the joys of getting together to

share nothing more than our time and ideas with one another is valuable in our alienated society. It can be energizing, quietly exciting, comforting, enjoyable.

e. Show a spirit of interest, of curiosity about life, of willingness to share at deeper levels. Single women have a special openness toward one another. The life of all of us would be enriched if we would talk together as openly and freely as many single women are able to do in their groups.

f. Give other single women reinforcement and encouragement. Few adults in our country seem to offer these to others. No one is so poor that she has nothing to give. We can offer a glance, a smile, a warm touch of the hand, goodwill, gratitude. It is equally important to be receptive to the same kindness from others.

2. *Working Actively to Help Others.* Single people have resources of time, energy, and caring which can be used both in dealing with individuals and in working with groups.

Giving time to others can do many things for you:

> Get you to think about others rather than yourself.
> Sharpen skills and talents you might not otherwise have used.
> Lead to the discovery of talents and aptitudes.
> Provide satisfaction. Work can be fitted to your schedule. A woman with very little time to spare can gain satisfaction from a few hours' work.
> Help you to find friends. A common concern or task brings you into contact with people who have similar interests and concerns.
> Expose you to an enriching variety of people, both those with whom you work and those whom you serve.
> Expose you to new experiences that you would not otherwise have. If you learn to understand them through reading and study, they can become a fascinating new interest.

Here are a few things you can do for people on a very personal basis:

- visit with them
- write letters for them or to them
- shop for them
- share a pet
- cook them a meal
- pray or do Bible study with them
- make gifts for shut-ins
- tape-record sermons for shut-ins
- read to them
- entertain them
- take them for a walk or a ride
- treat them to lunch or dinner
- teach them a skill
- listen to their stories
- make toys and dolls for disadvantaged children

Help is needed everywhere. Next door or across the world. Surely there is no excuse for anyone's not feeling needed in this world where so many millions of people are hurt, lonely, lost, or needy.

We have all known women who seemed to have everything and yet were unhappy and dissatisfied. In spite of good health, a good job, even fame, they felt no sense of fulfillment, no life-giving purpose.

Those who fail to use their gifts to a high purpose fail the people who might have been helped or healed by them. But above all, failure to love hurts the persons who do not love. It weakens them, limits their vitality, their zest for life, their joy in living.

Most people who volunteer their time find the rewards of a job well done very satisfying. One volunteer said: "A long time ago I recognized that instead of sitting home wringing my hands, I can get the most help when I give help. Someone who cares enough about others to go out and work for them is blessed beyond belief."

There are numerous groups that need volunteer services:

a. Traditional charities. These are often large organizations which use volunteers basically in fund raising. Much of the work is supervised by a professional staff.

United Fund
medical research
YWCA

hospital fund raisers
Public Broadcasting
Service
United Jewish Appeal

b. Political action and political campaigns. Dedication to an idea is paramount. Some functions of the volunteer might be fund raising, speaking, study, and action.

League of Women
Voters
prison reform
nuclear freeze

the peace movement
National Organization
for Women
Older Women's League

c. Personal contact. Many organizations require training and careful screening. Many women have benefited from such training and exposure to a new field of interest.

Big Sisters
Foster Grandparents
Literacy Volunteers
Meals on Wheels
hot lines
church women's groups

hospital volunteer
women's centers dealing with battered women, rape victims, runaways, incest victims

d. Miscellaneous groups. These may have short-term small jobs where women do vital functions such as getting out mailings, helping with clerical work, cooking a meal, etc.

This rough list barely indicates the variety of possible involvement. Use your imagination when choosing what you would like to do, taking into consideration your talents, gifts, and what you most enjoy. Explore carefully

just what an organized group offers and expects. Be careful to undertake a commitment that you can live up to.

If you form an action group, these guidelines might be helpful:

1. Conduct an interest survey in your place of business, school, church, or neighborhood to determine how many people would be interested in working with you on your proposed project.

2. Form a committee to organize what you intend to accomplish and draft a statement of purpose that will guide you in future meetings.

3. Get as many facts as possible: i.e., How many people in your area have a need for that service? Will it require money? If so, how much? How much time will be involved? Are government regulations applicable, such as state laws, neighborhood zoning? Where will you meet? How often? Can your group do it alone or will you need professional help? If so, what kind? Who would be willing to work with you?

4. Start small and slowly, with anticipation but not too many expectations.

LEARNING AND GROWING/NEXT STEPS IN GROWTH

As we have affirmed over and over in this book, single women have come a long way in a very short time.

We have a responsibility to be accountable and grateful for all that we have been given. We owe something to God for all the potential that has been implanted in us. We would treat one another and the earth in a more dignified way if we could rejoice in creation, if we knew how to be spontaneous and generous with one another. Adaptable women are able to recognize that the future is fluid. It takes shape by our daily shifting and changing

decisions, and each decision and event influences all the others. If we are careful to synthesize the best and let the rest go, we are able to contribute to new visions that may transform the world.

We desperately need women who are fully developed selves and whose energies are directed toward the fulfillment of the *whole* creation.

CHAPTER 6

God's Gifts for Singles

Single women who are open to God's love may experience through faith a variety of blessings: rootedness, community, celibacy, comfort, belonging, and fulfillment.

ROOTEDNESS

Ours is still a traditional culture that does not fully accept the various new functions of the woman in society. In ideology it still does not accept, at any psychological and political depth, the state of singleness. Such a traditional stance is harmful to the entire society because it does not take into account the changes of society itself. Such rejection of singleness only emphasizes the importance that single women have roots.

When I was first trying to find meaning in life, an observer compared me to a large tree with oversize branches blowing in the wind. He feared I might topple over at any moment. I was without roots. I was reminded of that recently when a divorced friend said, "I'm uprooted, feel afloat without an anchor." A widow spoke up saying: "Since John died, I've felt as though my inner core is drying up. I have no zest for life, no sense that life

will ever again have meaning." Another friend responded that she had always felt shaky and a little uncertain about life—especially the future. We all feel a need for roots, an anchor, something solid to hold us steady.

Millions of women have been uprooted and fragmented by the traumas that cause them to be single: divorce, death, and inability to marry. They often feel adrift, uncertain about life and themselves, unable to make commitments. They have not developed the good roots of their souls. This condition is unfortunate, because everyone needs to be committed and grounded to something beyond the daily round.

In the last analysis, the root of a woman is the source and security of her life. It is that from which she draws wisdom, strength, comfort, peace, and joy. Life has little meaning unless we are deeply rooted in God, in ourselves, and in a community of others. Paul the apostle puts it this way: "In God we live, and move and have our being."

We have many feelings, especially loneliness, when we experience ourselves without roots, without absolutes, without stability, without meaningful traditions, without a community or something that places us within the flow of history.

The world and everything in it appears to be shifting. Many things in which we used to root ourselves—extended family ties, religious and moral values, ideals and heroes, absolute truths, and trusted institutions—are constantly changing.

We notice a breakdown in moral absolutes in marriage, government, education, church or synagogue. Our knowledge is quickly outmoded by new inventions and new discoveries. Our roots are cut or mangled.

In order to live wisely we must feel connections with the generations that came before us and those that will follow. Otherwise we will be tempted to think that only

what happens in our own personal lives in this moment of history is important. We will be tempted to arrogance, thinking of ourselves as unique and special in ways that not only cut off the past but also the desire to build for future generations. Knowledge of and respect for our past provide a training ground for the present.

To be rootless in society leaves us rootless within our souls. It is important that we find some sources of security within ourselves. For many of us this has meant a commitment to search for and serve timeless values such as love, fidelity to friends and family, faith, hope, and selflessness.

It is also important for single women who have had their roots torn up to develop traditions or rituals of their own. Revisit regularly places you have enjoyed, redo things that were particularly meaningful to you. Celebrate events that you love. I know a woman who gives herself a birthday party every year. It is just the way she wants it, with the people she loves most. I have found each party delightful, and it is one that I look forward to every year. A tradition we have formed at the Women's Center is that of making ornaments and trimming the tree at Christmas.

It is equally important to stay in touch with people you love, take time for quiet, play more, and be less consumed by busyness. Create surroundings for yourself that will be a source of comfort and stability.

COMMUNITY

I long for community, for a group—of women, or women and men, of singles and families—who will be committed to an extended family and to the personal development which only this particular kind of commitment can elicit. I yearn to be one of a group of people who will not be afraid of one another and thus who can

learn to trust. These people would be available for support, affirmation, conversation, sharing a meal on a regular basis, and for criticism when I need it. This group would give my life some stability, some purpose beyond myself and the causes I associate myself with. I hunger not for one extended family to which I can belong but for others that will grow and make a chain of caring across our land.

When I talk about these longings, many other single women respond positively. They seem to yearn for the same closeness and warmth.

I must admit that while longing for a body of people with common interests, possibly living in the same place under the same rules (Webster's definition of "community"), I always hope that such closeness will not violate my needs for solitude, quiet, and contemplation. Such needs are reasons why single women might prefer their own room or apartment. Other reasons as expressed by the women themselves are: "It's easier to live alone. There are no hassles about the things I want or do," or "When other people are around I feel like a slob." The inference is that the woman can fantasize an image she is not rather than make an effort to become the best she can be. Or maybe she is really very neat but *feels* sloppy when exposed to the scrutiny of others.

One woman who comes from a large extended family and has lived in her own nuclear family as wife said: "It takes a great deal of patience and fortitude to live with other people. It takes willingness and readiness to forgive others while waiting for oneself or the other to change. Forgiveness is always necessary because there is always wounding—either conscious or unconscious—partly out of ignorance and partly out of sinfulness when two or more people are committed to one another. To know when to open one's mouth and when to keep it shut in love is a matter of skill. Not to run off when things

look bad, to feel no self-pity, is a matter of heroism in today's *'me'* culture. To know what needs to happen in, for, and with another without telling the person so, is a test of endurance. In spite of all this, to have a stable environment, to be cared for, and to have the chance to stretch and grow is worth it all."

Fashioning one type of extended family at New Berith, I have discovered that taking a risk with openhearted generosity in the giving of self and things and the opening of myself to many rejections and hurts from others have resulted in rewards far greater than the pain that I have had to endure.

Over the past twenty years many extended families have formed in all parts of the country: people who are sharing houses and lives by choice. They take many forms but have one goal: to create the homelike atmosphere of a traditional family even though most of their members are unrelated by either blood or marriage. For a description of these new life-styles, along with their advantages and pitfalls, see Eric Raimy's *Shared Houses, Shared Lives.*

For many single women in the twentieth century the nearest they come to community is to be near others at work, in a store, or eating in a restaurant. Yet belonging is one of the deepest desires a person experiences. To belong to another, a family, a group, or to God are urgent longings, often covered over with bravado or denied through fear of intimacy.

We Americans, usually so outgoing and friendly on the surface, are not good at forming deep friendships. There are many reasons for this. Some people do not trust that others can care about the real persons they are. Some are afraid to get close and they put out porcupine pricks to keep a safe distance. Still others find it almost impossible to commit themselves to much of anything, especially to other people.

One reason that singles groups seldom survive for long is that members are unwilling to commit themselves to leadership or even the simplest thing, like bringing refreshments. They drift from one group to another looking, looking for what? A mate? A friend? A sex partner? They are never satisfied, wishing for something to satisfy them—impossible without a faith in more than their own needs and desires. We need to learn how to develop in-depth relationships to get what we need most: a few people whom we can care about and commit to and who will care about us.

Dr. James Lynch in *The Broken Heart* makes it clear that death and disease (especially heart disease) are as much as ten percent higher for single individuals than for married people of comparable age. This is a strong argument, indeed, for belonging and for community.

We are creatures born for relationship. Infants whose physical needs are met but who are not held or loved will not develop, and often they die. Studies reveal that solitary older people die years ahead of those whose lives are involved with others.

We hunger for a warm look of recognition, the touch of a dear hand. A thought expressed and received makes sparks jump across an arc of bright hope—we are connected, alive! As much as the individual body cells need the greater whole, as our planet needs its solar system, so do we human beings need to be in harmony, in community with one another. If we have anything less, our bodies feel disease, our minds repeat negative circles, and our spirits curl up in pain, their songs forgotten.

CELIBACY

Of all life-styles, celibacy is the least understood and the most reviled.

The word "celibate," according to Webster, means "the state of being unmarried; the single life, especially that of one bound by vows not to marry." In this book I am using the word in the second sense. Not that a woman joins a convent and determines never to marry, but that she makes a conscious decision to live such a life for specified reasons for a period longer than a few weeks.

One writer in the first issue of the new journal *The Celibate Woman* (July 1982) is of the opinion that to be without a genital relationship for a week or so is to be celibate. This is not the classic understanding, nor is it mine. Such a view has the effect of distorting the possibilities of a vowed celibate life as the viable option it is. Paul (in I Cor. 7) made it clear that a decision not to have sex is not only viable but releases gifts to be used for the benefit of all (or the "kingdom of heaven"), and that it is a gift that few will understand. Those who are able to understand and who have the gift will find it difficult when other voices cry out, "What you are proposing is unnatural," or "An obsession with celibacy suggests a fear of life and a closing of doors," or "If a psychiatrist could hear you talking like that, he would say you are *sick!*"

It is true that some people who claim a gift of celibacy misuse it and are running away from life. A woman needs to be clear that she is choosing the celibate life for a higher purpose, not because she is trying to escape something. Another might wrongly take the vow only because she desires to be in a community that requires it.

To choose celibacy is a matter of choosing with reference to God's plan of love for the world and for her as a person. A true celibate has no disdain or distaste for marriage. She feels she could be married as easily as she could be single, but she chooses joyfully not to marry. A woman who does not understand her sexuality cannot be happily celibate: she becomes miserable and shows

unhappiness. She must, like other women, have the capacity for intimacy and deep friendship as well as human qualities of compassion and love.

How can a woman tell if she has a gift of celibacy? First, it will be revealed interiorly by the Holy Spirit in joy and peace. Some former nuns who remain celibate have explained: "God has designed from all eternity that some of us should be celibate and has therefore given us the qualities of mind and heart to be so." "I experienced a direct call to this life." "I fought for a long time against the conviction that this was God's will for me, but it was this conviction which has caused me to remain celibate after I left the convent." "I could not refuse what God was ever more clearly asking."

The next step is an act of faith: she accepts the gift and acts on it. Also the circumstances of life and the community of people help her to know. One woman said to me, "I felt God pulling at my heart, but later it became clear within the community of women with whom I lived." In my own life, when I was fifty, a priest discerned my gift: asked me if I had taken the vow of celibacy. As soon as he mentioned it, I knew my decision had been the right one and I was at great peace.

A few women I know have accepted the call to a celibate life for the sake of a call to love more people more. It is not giving up something so much as it is choosing to make oneself available in ways that would be impossible in most marriages. These women do not take vows to become nuns or live in monasteries but live fully and meaningfully in the world.

Such a woman may be at the desk across from you at work, talk with you at a party, or exercise with you at the club and you may never know. A true celibate is a perfectly normal, happy, warm, and loving individual.

Celibacy may be a condition of love and have its own freeing, energizing dynamics for those who, as Christ

said, "can accept it." I know that this has been true for me.

I hope all young people will have the opportunity to learn everything possible about varying life-styles, including celibacy, and be able to choose, with more knowledge and understanding than has been possible in the past, the one that is best for them.

Nuns. Twice a month for the past two years I have been visiting a cloistered nun. While nuns have a variety of life-styles, this sister was able to explain the distinctiveness of nuns' commitment to celibacy. When I was planning to write this book I asked her: "Why would any woman choose to live a life of solitude as a nun? Even though I understand the gift of celibacy, it seems incomprehensible to me that you would place yourself in a cloister." She replied:

"It is a mystery of human spirit that cannot be completely explained or understood. It is less a question of choosing than being chosen: a calling heard only in the heart. It is a very strong knowing—a conviction of wanting to embrace God as much as possible, the desire to be for others, and to be a channel of God's love for others. A nun wants to witness to the power present in each individual and to share the good news of God's love with them. On the other hand, the monastic way is at least as ambiguous and full of dangers as other ways. There is the danger of the heart drying up, the danger of religion replacing faith, the danger of spiritual pride, the danger of ignoring the radical secularity of the Christian vision."

This sister has helped me understand the similarities and differences between nuns and other single women, especially never-married women, and more especially those who freely choose to be single.

In common with other single women, she experiences a particular type of human loneliness beyond loneliness

so common to us all. She attains fulfillment of feminine sexuality without the complement of a close masculine relationship, most especially a genital one. Nuns are an integral part of a male-dominated society: the church. For other women it might be business, politics, education. Like other single women, a nun is experiencing an awareness and movement toward self-determination in that society.

Nuns have similar freedoms for self-expression because of the absence of obligations to a family, and similar access to opportunities in ongoing education, new careers, self-improvement. Yet they may also develop tendencies toward a narrowing of horizons, concentration on oneself, self-satisfaction, and wanting things ordered to one's likes and idiosyncrasies.

Though there are many similarities, there are also vast differences. A nun always belongs in a religious community. She can expect support from others and always has people with whom to share. One of the greatest fears of many women living alone is that of growing old alone. A nun does not have that fear. She will always be around others who care. Medical and health facilities and nursing care are available. Along with this community support she has economic stability, though a disadvantage might be that she is not financially independent.

The nature of her vows rules out any possibility of marriage or bearing children. A sex life is ruled out altogether.

She is always responsible for and accountable to others. All decisions are made in relation to the community, whether they have to do with goals, priorities, work, personal time, or acquisitions. She is taught to be interdependent in all ways.

A nun lives with very wide horizons because she lives for others within the convent and in the outside world. She cannot get too bogged down in personal concerns.

The life of the community depends on this. Though every nun may not attain the ideal, the vision of what she should strive for is always there. The support, atmosphere, spiritual input, and participation with others in ministry which are inherent in the community aid its members in maintaining psychological and spiritual health to an advanced age. "Such spiritual inner growth is what frees us from monotony," says Sister Elizabeth.

COMFORT

As single people of different marital backgrounds share their problems and feelings, they begin to appreciate that their common concerns about loneliness, going out alone, facing society's prejudices, and coping with single life in a couple-oriented culture outweigh the differences among them. This is especially true a year or more after the initial trauma of knowing that one must face life alone. I would hope for many opportunities to bring women of different states of singleness together for mutual understanding and support. Our similarities are more significant than our differences and can help us find together positive ways to achieve life-affirming goals. We can learn from one another. We can help one another see our role of single women as a challenge and not a liability.

Reflections. I would like to share with you some of the theological reflections that were helpful to me at three critical periods in my life: when I thought I would never marry, when I was widowed, and when I was divorced. I hope they might help others find their own word of new life.

Never-Married. Relationships and roles do not determine our individual value and significance. Jesus honored marriage. Again and again he asserted that full,

complete, dedicated service to God is possible regardless of family or marriage or lack of both. Through service we find fulfillment. Jesus himself practiced this as a single person in his own earthly life.

God desires to set us free from all stereotypes, bondage, and conformities to this world that are not in accord with God's own will. The authentic person is one who does not permit the context within which she lives to determine her actions or define her. The law—that is, the customs of the culture—does not determine who she is. She allows spiritual instinct to guide her. Such a person is open to the present and the future. Such a person is free to challenge the arbitrary restrictions imposed by society's narrow thinking and acting: its crippling stereotypes.

One can compare the spiritual presence of God to the air we breathe, surrounding us and working life within us. The Spirit is always present, a moving power, sometimes manifest in great personal ecstasies or in great moments of history as the mighty acts of God. Mostly, however, the Spirit moves more quietly, entering our human spirit and remaining alive within us even when we would reject it. Most often the Spirit works in a hidden way in our daily encounters with other men and women in the world. God as Spirit is available to every woman regardless of marital status. God has written the law on the heart of each of us in a new covenant, and "no longer shall each person teach his (her) neighbor and each his brother (sister) saying, 'Know the LORD,' for they shall all know me, from the least of them to the greatest, says the LORD" (Jer. 31:34). Thus a woman is empowered to live responsibly as a single person and need not depend on another. There is absolutely no limit to the resources that God can supply. He longs to give to us all freely and without limit.

The Divorced Woman. The divorced woman has feel-

ings of guilt, hurt, and failure that sometimes seem overpowering.

Repentance, as an act of turning back to God, serves to cleanse one from the guilts and fears engendered in alienation and separation and is a necessary requirement for forgiveness. Forgiveness is a necessary requirement for newness of life. For Jesus Christ, and therefore for the Christian, there is no limit to forgiveness, assuming always that there is true repentance on the part of the forgiven one. Jesus says that if someone sins, you are to rebuke the person, and if the person repents, you are to forgive the person; and if the person "sins against you seven times in the day, and turns to you seven times, and says, 'I repent,' you must forgive" the person (Luke 17:3–4). In forgiving our estranged spouses, we open up liberation for ourselves, though that must not be the reason for our repentance and our acts of forgiveness.

In the midst of death, life is born. In the midst of the death of an old relationship, life has an opportunity to start anew. Jakob Boehme said: "I can neither write nor tell of what sort of Exultation the triumph in the Spirit is. It can be compared with nought, but that when in the midst of death life is born, and it is like the resurrection of the dead." We know, as Jesus taught, that a seed must drop into the ground and die before the new plant can grow.

The New Testament gives us place and freedom to experience anew the grace of God which comes always as judgment, always as power, always as forgiveness, and always as claim. "Let grace abound," not that there might be sin, but that "we might walk in newness of life" (read Rom. 5:20 to 6:4). The effect of God's grace, this Holy Spirit which Christ gives, is felt as liberty, a release into the unlimited possibilities of a personality set free to become what God intended. The law leaves a person to rely on human strength and challenges her to do her

utmost, to strive for the best. The good news of the Spirit, on the other hand, brings a woman before the gift of God and challenges her to make the inexpressible gift of love and forgiveness the basis for her life. It is not cheap grace, of course: the cost is the whole person, not just external behavior.

Whatever your concern about past decisions, feelings of failure, or having done wrong, know that God does not care about the past. The Spirit cares only about a relationship with you right now. That is the excruciating simplicity and unutterable wonder of God's love. "Come to me, my little one, and I will give you rest." "I would put my wings around you, but you would not let me." "You are carved on the very palm of my hand." "Can a woman forget her sucking child, that she should have no compassion on the child of her womb? Even these may forget, yet I will not forget you." Hundreds of other biblical passages attest to the innumerable times God has forgiven poor judgment, mistakes, past errors, even the most heinous of crimes.

The Widowed. The widow, most often, has feelings of loss and desolation. May these thoughts comfort you:

God honors and enters into the grieving process. God in both Old and New Testaments grieves, weeps, cries, even cries out like a woman in travail. Jesus wept over his friend Lazarus, over the people of Jerusalem who would not turn to God, and over his friends who deserted him by sleeping when he felt he needed them in the Garden of Gethsemane. Paul speaks of his grief and the grief of many others. Modern doctors and psychologists have advised us, for our own health, not only to grieve over the death of or separation from a loved one, but over each stage of our own emergence from grief. As we die to the old we are born to the new. As Abraham Heschel writes: "He is partner to our anxieties. A man in need is

not the exclusive and ultimate subject of need: God is in need of him."

God longs to "comfort all who mourn; to grant to those who mourn in Zion—to give them a garland instead of ashes, the oil of gladness instead of mourning, the mantle of praise instead of a faint spirit; that they may be called oaks of righteousness, the planting of the LORD, that he may be glorified" (Isa. 61:2b–3).

For everything there is a season, a time and place as Ecclesiastes 3 tells us. "There is a time to weep and a time to laugh, a time to love and a time to hate." God not only knows how painful it is to lose one we love, to face that pain, and to try to build a new life without that person, but God also recognizes our need to love and play and celebrate life even in the midst of pain and death.

When God came to create the world, to reveal what was hidden in the depths and to disclose the light out of darkness, they were all wrapped up in one another. Light emerged from darkness: from the impenetrable came forth the profound. God created and creates out of chaos. God invites us to be co-creators in becoming new people in a new life, singing a new song.

BELONGING

Many passages in the Bible show clearly that in the new family of God in Christ there will be no discrimination or prejudice against people of different races, sexes, or classes, and the barriers we erect to divide us will fall. The Old Testament God is always most concerned for the person who is on the edge of society. Do not oppress the widow, the fatherless, the sojourner, or the poor was a constant admonition.

In our society the single woman is still on the edge, marginal, outside the main flow of society. One of the

reasons Jesus annoyed the good religious people of his day was that he insisted that God's love was not restricted to them but was available to the despised, rejected, and discriminated against. God's love is unconditional and universal. It is from this knowledge that we can draw strength to fight the good fight and win.

There is a growing interest within church and psychiatry to have laypeople learn to help one another. This is a promising sign especially for those single women who feel the need to "mother," to nurture, to help bring others into the fullness of life but have no outlet. The single woman can learn how to listen and to interact with another—to be friend and neighbor. I do not imply that many married women do not do this, because they do. But single women who have the motivation can find more time, money, and energy to pursue such activities.

A person I counseled had been widowed, lost a child, and some years ago again married and divorced a man who was an alcoholic batterer. To my happy astonishment, this woman met me after a presumably lonely Christmas with a smile on her face and a lilt in her step. She had been contemplating suicide when she realized that she could probably find someone worse off than she was. She called her pastor, a woman who wisely gave her the number of a parishioner who had no family, was suffering from a terminal illness, and would probably not have anyone to spend the holidays with either. They struck up a friendship that day which endured to the end of the older woman's life. They gave each other warmth, occasional companionship, someone to reach out to. My counselee told me that this new relationship had inspired her with a desire to love and serve the terminally ill. Within three years she had obtained the necessary credentials for the work that she realized she had been called to do. By looking outside herself she was led to

new life. Today she is a well-balanced, integrated, happy woman who brightens the lives of many.

Why did Jesus hold spellbound those who listened to him? It was because he showed them they were not helpless victims in the grip of fears, hates, the past, the present. They were the salt of the earth, the light of the world, the leaven in the bread of life. He offered them a new idea: that responsibility (or obedience to the standards of God) and freedom are inseparable. Where is the joy of living in a society in which all obey like automatons and no one is free? Or in which all are free and no one takes responsibility? A great thirst in the people who heard him rose up to meet the living water. They were caught up in the love of God, the willingness to follow the Spirit, which is perfect freedom; they became the servants of the Spirit and thus free men and women. It was in Jesus that the people, soul-hungry, eager for meaning, thirsty for wisdom, found meaning and purpose for their lives. Even though we must give up many things in order to gain fullness of heart, there is no freedom like that of finding meaning in life.

If we find ourselves unhappy, depressed, ungrateful, self-pitying, we have chosen attitudes that lead toward death of the personality and of our ability to develop enduring relationships.

Yes, we do choose what our lives will be. We had no choice about who our parents were or about our early childhood. But there comes a point in life for each of us when we are faced with the question, "What am I doing about that?" And an inner voice that whispers, "You should be doing thus and so." Nevertheless we often go on in our uncomfortable ruts, choosing to remain in the old situation rather than bearing the pain and conflict of moving into new life. Many women have said to me, "I've got something that keeps me from relationships, and I just can't seem to overcome it," or "I won't let go of

the rage I feel," or "I won't be honest with that person." They choose to hold on to the past, to turn from honestly facing the present, to fail to act.

Our gifts and talents are not given for ego satisfaction, though this may be a by-product. Our gifts are to enhance the community, to bring unity, faith, wisdom, and ministry to all. What does it mean to be empowered by the Holy Spirit? It means that we accept our gifts and give them back to God and to the community with what we have been given.

Some of the gifts God gives us are not glamorous. One of the most important is that of suffering: a gift that most single women have in abundance. It is through suffering that we seem to learn the most and become mellowed and humble enough to show true compassion toward others. The Holy Spirit empowers us to love, to be peaceful in our hearts, to be tender and kind and gentle with one another, to care about one another's welfare above our own, to be strong in the face of crises, and long-suffering in the presence of pain. We can find fulfillment only when we are connected with this high purpose.

Many women are victims of certain illnesses because they do not use their gifts. They become bored, depressed, have feelings of helplessness and hopelessness that can cause physical ills. One reason may be that we have been socialized to be dependent rather than independent, to seek to be taken care of, which prevents us from developing our full potential intellectually or emotionally.

For the past few years volunteerism has had a bad press in the women's movement. I understand that it was important to prove that the time, talent, and expertise women were giving to volunteer organizations was worthy of pay and the fact that the women were unpaid often indicated a lack of recognition of their value. This we

have now accomplished. At this stage I decry the continuing denigration of volunteer work. To give of ourselves, without pay, has rich satisfactions that an ordinary job cannot provide. Without volunteers many worthwhile organizations are suffering and are unable to continue their work. We single women today can earn and develop support in times of crisis, affirmation for what we do, a role and a place in the community, stimulation and challenge, and reaction from others. Volunteer work has been and should remain an important way for women to establish ties of usefulness and belonging.

FULFILLMENT

God finds us not only acceptable but worthy of respect and love. God waits with eager longing for us to turn and embrace him. When we finally say "Yes!" we find a new parent, a new family, a new personality. If we did not know it before, we then realize we now have gifts and talents that were hidden. We recognize that we are desperately needed by God and that a job has been waiting that only we can do. This knowledge gradually fills us with a new humility coupled with self-esteem and a growing fulfillment.

Fulfillment does not come through striving to satisfy the self. Rather, it is a by-product, a fruit of allowing the Spirit to teach us and lead us to find a need and fill it. Fulfillment comes with using our gifts and talents to their fullest capacity, to having a goal larger than we think we can fill and then keeping ourselves open at all times for new insights, new opportunities, new life. "The person who abides in me ... bears much fruit" (John 15:5b).

In order to earn a living we may work at jobs we do not like or are not truly gifted to do. We may develop certain talents or skills without ever asking what we were meant

to do, what only we can do. Less often is there anyone who helps us figure out what our true gifts are or encourages us to develop our fullest potential. Single women often feel they cannot do what they want to do or are not worthy of achieving what is possible for them.

Depression is often the result of a lost dream. If someone dreamed as an adolescent or a young woman of doing something and nothing came of it, she may become depressed without being conscious of the cause. Such depression is accompanied by feelings of anger, guilt, fear, and other debilitating conditions which, if prolonged, may result in physical ills such as colitis, headaches, fatigue, or heart disease.

It is our responsibility to change these conditions. The more we try to use our gifts, the healthier we will become. The secret is to use or give away what we are given, not hold it to ourselves.

One important way of improving our self-image is by doing things for others. Every self-improvement program from Alcoholics Anonymous to the Dale Carnegie Course on human relations makes this point. However, for this to succeed, it must be a two-way street. We must have give-and-take relationships rather than those in which one person does all the giving and the other all the taking.

The Talmud says: "If I am not for myself, who will be for me? And being only for myself, what am I?" The paradox of giving is that great richness comes back to one.

True maturity means accepting one's own weaknesses and needs, limitations as well as potential, being able to recognize and to say, "I need you."

For fulfillment we also need a sense of humor as we look at the true worth of things. So many of us take worldly, transitory things too seriously. Much of what happens in life is laughable, even ridiculous. Human

effort is a *human* effort, after all. It is not invested with utter seriousness as are the things of God such as peace, compassion, joy, love, justice, patience, and praise for who we are and what we have been given. Take life more lightly. Hold it gently. Laugh at the incongruities: take most things with a grain of salt.

If we are truly appreciative of ourselves as spiritual beings made in God's image, with the power to recognize and use our gifts, we can laugh at ourselves. If we do not believe we are worthy, then we will be afraid that whatever we do is wrong. We will become rigid and unable to laugh at ourselves or to take delight in the world around us.

Within each of us there is the power to grow, to be more effective, to relate better with others, to find greater satisfaction in what we do. But let us enjoy life more and struggle with it less, be less hurried, be more leisurely and contemplative. When we are relaxed and open, life seems to fall into place with greater ease.

We need to take every opportunity possible to enrich our inner life, maintaining the proper balance between the development of body, mind, spirit, psyche, senses, and the decisional life. All basic (not learned) aspects that each of us is given are good and worthy. Try not to cut off or deny any one of them. For years I found it very difficult to accept my body: I was too tall, too *big*. I felt I was an embarrassment everywhere I went—especially in a bathing suit. Naturally, I missed a great deal of fun through such denial.

Let us keep alive within us the heart and spirit of children, with a child's sense of wonder at the awesome spectacle of life and appreciation for all beauty of sight and sound.

Let us delight in life as it is. Instead of searching for what we do not have and resisting full acceptance of what is now at hand, let us enjoy ourselves and the

people we encounter along the way. As our appreciation grows, we will become more fulfilled and our state of life will become more satisfying.

Ask yourself questions such as, "If I had my life to live over, what would I do differently?" Then try the difference. Or, "If I had no encumbrances and all the money I could possibly use, what would I do with my life?" Why wait? Begin in little ways now. Take some risks to make a dream come true.

There are good things in every person's life that the person can celebrate every day but seldom does. Make a list of all the things you have to be thankful for. If you bought this book or a friend gave it to you, begin by being grateful that you can read. Do not take such a blessing for granted: not everyone can. I think you will be pleasantly surprised by how long your list may be.

A friend said to me the other day: "I was having such a great time the other morning just playing with my cat that I began to feel guilty. Before the day was over I was deeply depressed." How many of us feel that way? And why? We were created to delight in life, delight in our humanness, delight in all that has been given to us. To be ungrateful to our merciful God is to take away the joy of living. To be grateful for all that enters our lives is to utter the most profound of prayers.

In the past years we have seen hundreds of women change their way of life and their values as they came out of marriage. In the midst of crisis they often came to know the Spirit as a source of strength, power, and comfort as well as of creation. But their conversion failed to carry them beyond solving their own, immediate problems.

In numerous ways the future has already arrived, but many single women are so concerned with the day-to-day struggle for survival that they may not be truly conscious of it. Many of us grew up in a time when the

future seemed assured. The fairy tale told us to be good, find the love of our life, be a good wife and mother and we would live to a happy old age. Some older women feel confused at the rapid and often cataclysmic changes of the past few years, not knowing how to enter the new era. Yet the resulting pain, suffering, and grief can open new dimensions of life: compassion and appreciation. If we do not shut them off, for fear of being hurt again, we are able to be openly affirming.

Because many of us will not be able to or will not choose to marry or remarry, we can help others to understand that fullness of life does not come from leaning on someone else but from inner strength.

Too many people today are spiritually unconscious. The society we live in is a greedy, materialistic, extremely alienated one. We are not nurtured by great visions. We are most often fed trivia, which is insufficient to satisfy the longing of the human soul. And our culture tries to put us to sleep or to keep us there if we are asleep.

Single women must help remold the culture if we are to ride the wave of the spirit of the future with joy. My plea is that we single women of faith involve ourselves in life-giving changes for a world free or at least lessened of violence, greed, and alienation.

But how do we develop attitudes of gratitude, play, celebration, relaxation, and joy? Through the disciplined and steady work of Bible study, prayer, meditation, and contemplation, which will develop sensitivity in us. For this we will need to use all our gifts and energies, our love and rejoicing in the service of God, and daily forgiving all offenses against ourselves. The fruits of such a life are deep peace in the heart which then exudes love and hope.

AFTERWORD

Single and woman. Both of these states of being are considered weaknesses in our society. The reality is that both, understood correctly, are strengths. Let us once and for all refute these false beliefs and attitudes.

Women were trained to care, to respond, and to be tender. Let us build on these abilities! They are the very qualities that men, women, and the world need at this time in history.

Military might will not make our society happy and secure. But the might of kindness, forgiveness, reaching out in love is yet to be tried in any substantive manner. This is the new frontier. Let us be on the front lines.

God created us female and saw that as good, so why should we distort the image? Let us enjoy what we have been given and go on to discover even more fully, to allow ourselves to be created even more completely.

Meditation on I Cor. 7:17–24

"Lead the life which the Lord has assigned you,
Do what God has called you to do."
This should be your focus and your goal.
Were you single when God first got through to you?

Then God wants to use you as a single person,
> that is, as you are.

Do not put your mind on marriage, but on the Lord.

If God believes your gifts can best be used in marriage,
> God will call you to it, reveal your gift to you.

In the meantime, "every one should remain in the state
> in which she was called."

For it is best to be a slave of Christ
> —doing what God commands
> —following the dictates of the Word of God.

Such slavery sets you free,

Such slavery opens your eyes to the world around you.

Such slavery gives meaning:
> —a purpose in life
> —a sense of self-esteem
> —the strength of inner clarity and confidence.

You were bought for freedom,

You were bought with a price.

Do not listen to the voices of human beings, listen to God.

In whatever state you were called,
> remain with God,
> and look at Christ, the Giver of Life.

Ask God how you are to use your single state
> and become free.

BIBLIOGRAPHY

Adams, Margaret. *Single Blessedness: Observations on the Single Status in Married Society.* Basic Books, 1976.
Ahern, Dee Dee, and Bliss, Betsy. *The Economics of Being a Woman.* Macmillan Publishing Co., 1976.
Barkas, J. L. *Single in America: A Candid Look at the Rewards and Drawbacks of Living Single.* Atheneum Publishers, 1980.
Bequaert, Lucia H. *Single Women, Alone and Together.* Beacon Press, 1976.
Bird, Caroline, and Briller, S. W. *Born Female: The High Cost of Keeping Women Down.* David McKay Co., 1968.
Brown, Raymond Kay. *Reach Out to Singles: A Challenge to Ministry.* Westminster Press, 1979.
Caine, Lynn. *Widow.* William Morrow & Co., 1974.
Collins, Gary R., ed. *It's O.K. to Be Single: A Guidebook for Singles and the Church.* Word Books, 1976.
Crook, Margaret. *Women and Religion.* Beacon Press, 1965.
Dowling, Colette. *The Cinderella Complex: Women's Hidden Fear of Independence.* Summit Books, 1981.
Edwards, Marie, and Hoover, Eleanor. *The Challenge of Being Single.* J. P. Tarcher, 1974.
Epstein, Joseph. *Divorced in America: Marriage in an Age of Possibility.* E. P. Dutton & Co., 1974.
Goergen, Donald. *The Sexual Celibate.* Seabury Press, 1974.
Lynch, James J. *The Broken Heart: The Medical Consequences of Loneliness.* Basic Books, 1977.

Madeleine Sister. *Solitary Refinement*. London: SCM Press, 1972.
Nouwen, Henri J. M. *Reaching Out: The Three Movements of the Spiritual Life*. Doubleday & Co., 1975.
Payne, Dorothy. *Life After Divorce*. Pilgrim Press, 1982.
———. *Women Without Men: Creative Living for Singles, Divorcees and Widows*. United Church Press, 1969
Raimy, Eric. *Shared Houses, Shared Lives*. J. P. Tarcher, 1979.
Rolheiser, Ronald. *The Loneliness Factor: Its Religious and Spiritual Meaning*. Dimension Books, 1979.
Tournier, Paul. *Escape from Loneliness*. Tr. by John S. Gilmour. Westminster Press, 1962.
The United Presbyterian Church U.S.A. *Sexual Harassment: Naming the Unnamed*. Council on Women and the Church, 1982.
U.S. Bureau of the Census. *Statistical Abstract of the United States: 1981* (102d ed.) Washington, D.C., 1981.
Welch, Mary Scott. *Networking: The Great New Way for Women to Get Ahead*. Harcourt Brace Jovanovich, 1980.